Starring
THE PLAZA

Starring
THE PLAZA

HOLLYWOOD, BROADWAY, AND HIGH SOCIETY
VISIT THE WORLD'S FAVORITE HOTEL

PATTY FARMER

FOREWORD by
Mitzi Gaynor

BEAUFORT
BOOKS

ALSO BY PATTY FARMER

The Persian Room Presents
Playboy Swings
Playboy Laughs

FIRST EDITION

Published by Beaufort Books, New York, NY.

Manufactured in China

ISBN 9780825308468

Cover and interior design by Ashley Prine, Tandem Books, Inc.
Photo Research by Frank Vlastnik
Editorial Development by Laura Ross
Illustration on Page 2 by Sujean Rim

To all of the great artists who created the work that
fills these pages, thank you for putting stars in our
eyes and making us believe in magic. As for the
Plaza, there is only one thing I can say:
There's no place like home.

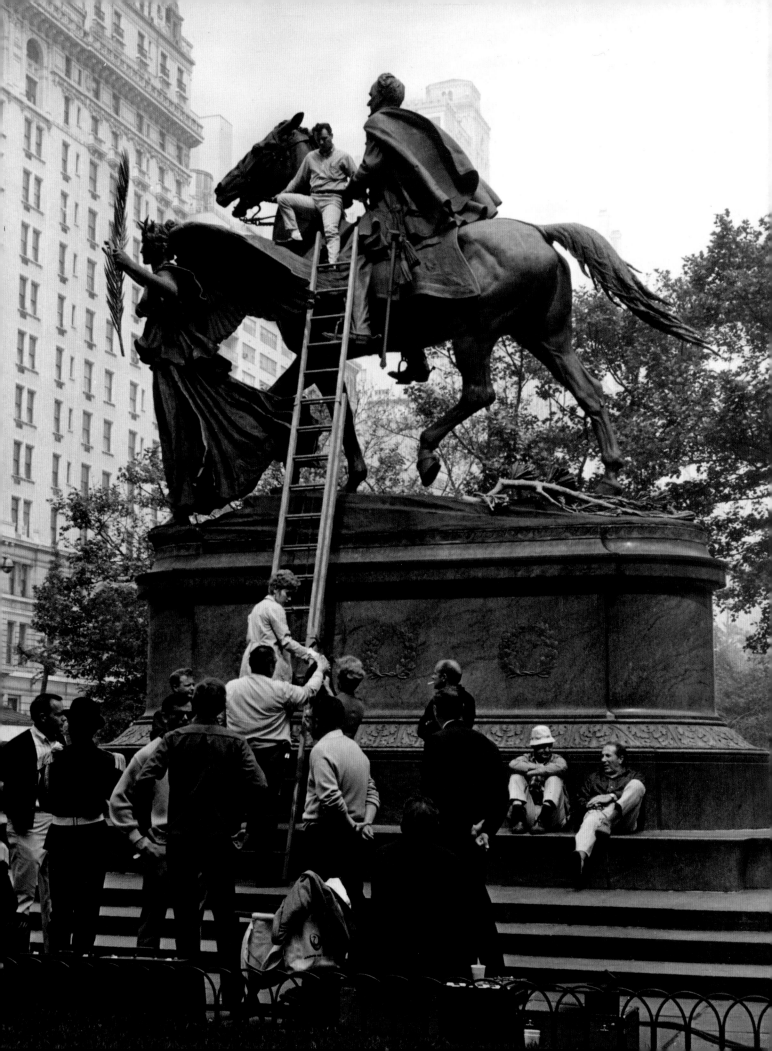

Contents

OPPOSITE: No, the cover image is
not a result of Photoshop magic.
Shirley MacLaine actually scaled
the statue of William Tecumseh
Sherman in Grand Army Plaza
during the showstopper "I'm a
Brass Band," in the 1969 movie
version of the hit Broadway musical
Sweet Charity. Director Bob Fosse,
trademark cigarette in mouth,
supervises.

Foreword

The Plaza *is* glamour; it's dripping with chic. From Marlene Dietrich at her most "Marlene"—simply devastating the throng at the Persian Room—to the fabulous ladies sipping tea in the Palm Court, it's everything you hope New York will be when you're dreaming of being a part of it. And besides all that, Eloise lives there....*Rawther!*

How could I not adore the Plaza? Oh, the memories. I first gazed up at its beautiful façade in 1946, when I was in the corps de ballet in a Broadway show called *Gypsy Lady.* Since there were often more of us on stage than in the audience, I used to cheer myself up by standing across the street from the hotel's grand front entrance and watching the elegant people streaming in and out.

In 1954, my husband Jack and I spent our honeymoon there while in town to attend the New York premiere of my film *There's No Business Like Show Business.* On another visit, I met Eleanor Roosevelt. And it was while staying at the Plaza that I learned this all-important lesson: If you're hosting a cocktail party in your suite at 7:00 pm, do not, I repeat, DO NOT, order the champagne and caviar to arrive at 7:00 pm! It may not get there until 8:30.

One afternoon, at the height of my movie star days, I was standing outside the Plaza, all teeth and eyelashes, wearing my jewels and a new mink coat and looking rather smashing, thank you very much, when I noticed three young girls

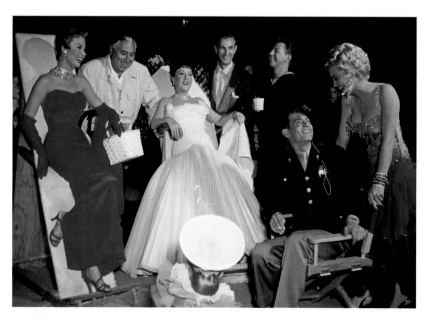

Resplendent in red—and holding her own amidst a stellar cast—Mitzi lounges between takes with the company of the 1954 film *There's No Business Like Show Business.* That's Ethel Merman in the center, surrounded (clockwise from Mitzi) by director Walter Lang, actors Johnnie Ray, Donald O'Connor, and Marilyn Monroe, and vocal director Ken Darby.

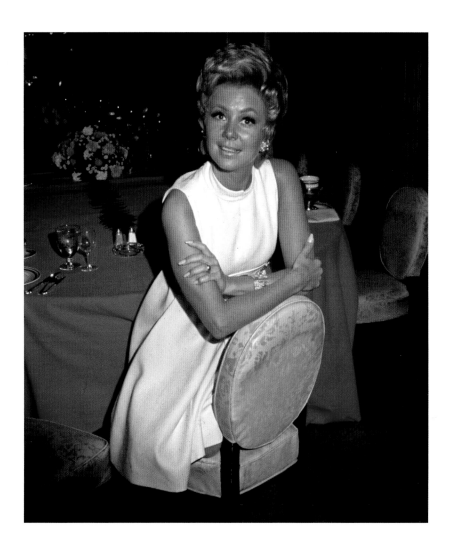

Mitzi sparkles as brightly as her surroundings, the Plaza's White and Gold Room, in 1970.

walking down the street toward me. I just knew they were about to ask for my autograph; my hand was virtually poised for the pen they would slide into it. Well…let's just say they showed me who the star really was. As they hurried past me, one of them turned around and said, "Hey Mitz, Brando's at the Essex House!" Note to self: There's always somebody hotter up the street.

That said, there's never been a *place* hotter than the Plaza. Movie stars, movie makers, society folk, and all of the hoi polloi that surround them have always known that. For evidence, look no further than the beautifully illustrated tome you're currently holding. In grand style and with her trademark élan, Patty Farmer—that expert chronicler of all things fun and fizzy from the Persian Room to the Playboy Clubs—has done it again. This time, she's captured all of the movie, TV, and stage magic that the Plaza has conjured over the course of its century-long reign as the epicenter of New York sophistication.

Thanks to Patty, we all get to go along for the ride. What fun!

—Mitzi Gaynor

P.S. See you at 7:00 pm. I've already ordered the champagne and caviar.

Introduction

I was seven years old when I first stepped inside New York City's celebrated Plaza Hotel. My mother took me to afternoon tea at the fabled Palm Court and, needless to say, I was captivated. Could there be a more enchanting spot for a little girl? Sitting there, feeling very grown up with my white-gloved hands folded neatly in my lap, I marveled at the tiny sandwiches and cakes, the elegant tea service and tableware, and the graceful waiters—gloved just like me—gliding among the trees. Trees indoors! I had never seen such a thing. I wanted that afternoon to last forever.

Of course, I wasn't the first little girl to feel at home at the Plaza. Kay Thompson and illustrator Hilary Knight, creators of Eloise, could have chosen any hotel in the world as the home base of their inimitable scamp, but felt wholeheartedly that the Plaza was RAWTHER the perfect place for her (as Eloise herself would no doubt put it). Perhaps that was because Thompson lived there at the time. It's hard to believe that Eloise would be in her sixties today, as her unchanged portrait continues to hang prominently in the lobby and the hallways still seem to echo with her laughter. She has been brought to life several times by Hollywood, and each time, the hotel has had a starring role as itself.

But I am getting ahead of myself. I guess chasing after Eloise will do that!

From the day it opened, on October 1, 1907, the lavish nineteen-story French Renaissance building on the southeast corner of Fifth Avenue and Central Park South was portrayed as the grandest hotel in the world. No detail went unconsidered in what seemed more like a chateau for royalty than a way station for out-of-towners. Some 1,650 crystal chandeliers, numerous Italian marble stairways, and miles of hand-laid gold mosaic floor tiles contributed to its opulence. The Plaza simply had to be experienced, and anyone who was anyone flocked there.

Mr. and Mrs. Alfred Gwynne Vanderbilt were the first guests to register, followed by all of high society at one time or another. Broadway and movie stars, presidents and kings, captains of industry, and media "flavors of the month" have all vied to be photographed in its various salons, ballrooms, and sitting rooms. And, no matter how big the event or story, the Plaza was always a part of the caption.

Truman Capote's notorious annual Black-and-White Ball was held in the Grand Ballroom; the first one took place on November 28, 1966, hosted by

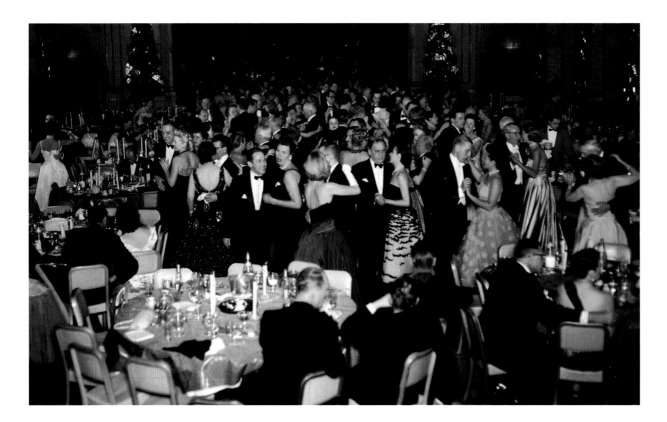

Katherine Graham to celebrate the publication of Capote's *In Cold Blood.* Lavish upper-crust weddings have always been a staple; during prime months, hardly a weekend goes by without a shower of rice on the majestic front steps. And in the heyday of its famous nightclub, the Persian Room, the world's hottest cabaret acts sang for their supper—and lavish accommodations—on a nightly basis. (But that is the subject of another book!)

Celebrities from Marilyn Monroe to the Beatles have chosen the hotel's posh suites as their "homes away from home," and have continually pressed it into service for what we call the "four P's": press conferences, premieres, publicity events, and—of course—parties.

It stands to reason that the imaginations of Hollywood's writers, directors, and producers would be captivated by this icon of glamour and gracious living. Set a scene at the Plaza and you are immediately communicating volumes about your characters' lives, dreams, and aspirations. Dozens of films have been shot there over the years, and when that wasn't possible, the Plaza's immediately recognizable public and private spaces have been re-created on sound stages and in locations far from New York. (We call these scenes "Plaza Pretenders" and they just aren't the same as the real thing—but you can't blame Hollywood for trying.)

Broadway plays have been set at the Plaza as well—most notably Neil Simon's *Plaza Suite*—providing set designers with the estimable task of invoking the hotel's unmistakable opulence on stage. The Plaza even housed an Off-

One of the highlights of the New York social season, the annual Fan Ball (held for the benefit of the Children's Cancer Fund of America) attracted a Who's Who of Manhattan society. This one took place on November 18, 1955. (Turn to page 111 to see Lena Horne throw it down at the Ball two years later.)

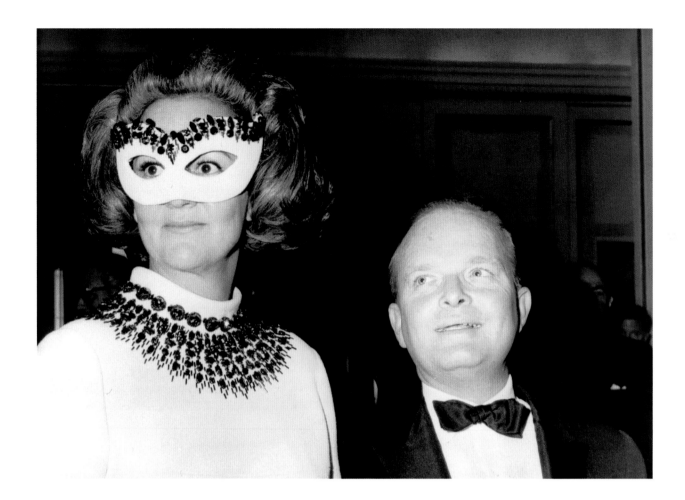

Broadway theater at one point! And television has gotten in on the act as well, in shows ranging from *That Girl* to *Gossip Girl*, *The Sopranos* to *CSI*.

This book is meant to celebrate the Plaza as a star of stage and screen, and we've scoured the archives to show it off in all its glory. Yes, that's really the grand lobby in *Home Alone 2*, the Oak Bar in *North by Northwest*, and the Persian Room in *Sabrina*. And who can forget the front façade in the pivotal scene of *The Way We Were?* The Palm Court, the Terrace Room, and many hotel suites have had their moments on the screen as well—but why read about it when you can begin turning the pages and see for yourself?

My seven-year-old self, sitting primly in the Palm Court, could never have dreamed that someday I'd live at the Plaza—but I do. And every day, as I walk through its doors, I sense its status. As much as the Statue of Liberty, the Met, and Yankee Stadium, the Plaza is a New York icon. Its appearance on screen is shorthand for New York itself—or a certain aspect of New York. The Plaza is New York's grande dame—and she's a hell of a good actress, too.

—Patty Farmer

Washington Post editor (and guest of honor) Katharine Graham and Truman Capote at the Black and White Ball, held in the Grand Ballroom of the Plaza in November 1966. Already at the peak of his celebrity, Capote decided to further raise his profile by throwing a masked ball inspired by the "Ascot Gavotte" scene in the film *My Fair Lady*. It was attended by the biggest names in politics, literature, high society, and show business—and people went to extraordinary lengths to get on the guest list.

THE PLAZA
on
Screen

While exploring the voluminous corridors and out-of-the-way corners of the Plaza, I've happened on numerous film shoots in progress. A few years ago, it was a thrill to perch quietly in a corner and watch Kate Hudson and Anne Hathaway film a scene from *Bride Wars*. (My companion in the darkness was Lance Armstrong, who was dating Kate at the time).

The list of directors who have insisted on shooting scenes at the iconic hotel reads like a Who's Who of Hollywood: Alfred Hitchcock, Sydney Pollack, Martin Brest, David O. Russell, Abel Ferrara, Paul Mazursky, Elia Kazan, Francis Ford Coppola, Walter Hill…the list goes on. Still others, whose budgets wouldn't allow for location shooting, attempted (for better or worse) to recreate the Plaza's special atmosphere on Hollywood sound stages. Who can blame any director for wanting to tap into that Plaza magic? For decades, the Plaza has served as visual shorthand for New York City at its most romantic and glamorous. It's safe to say that the bittersweet reunion scene between Barbra Streisand and Robert Redford in *The Way We Were* just wouldn't be the same if it had been set in front of the Times Square Holiday Inn.

The Plaza has appeared on the small screen, as well, in TV shows from *That Girl* to *Gossip Girl* as well as an assortment of music videos. I can personally attest to the excitement generated by Mariah Carey when she pranced endlessly up and down the hotel's red-carpeted front steps as part of her video for "Obsessed." One of our real-life doormen is still bragging about playing himself in that one.

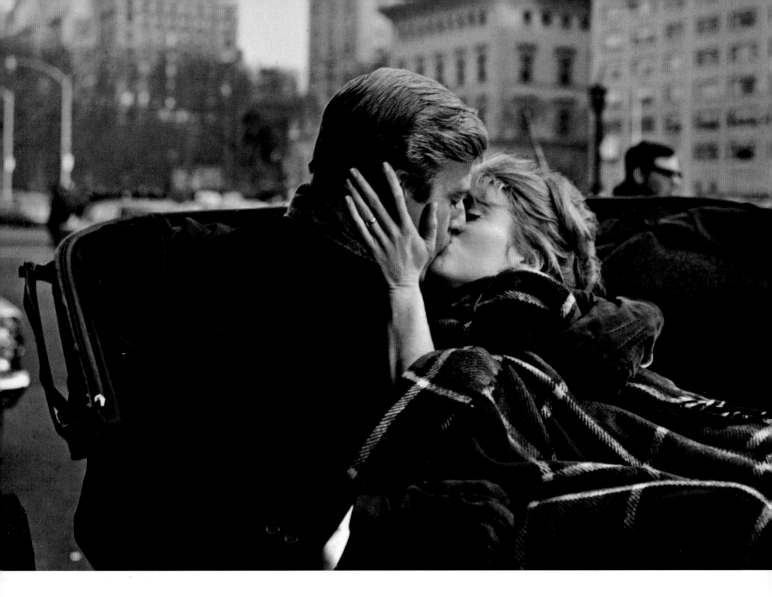

BAREFOOT IN THE PARK

Directed by Gene Saks
Screenplay by Neil Simon
Released in 1967

Based on Neil Simon's 1963 comic play of the same name, *Barefoot in the Park* tells the story of mismatched but loving newlyweds Corie and Paul Bratter, starting their adult lives in a tiny walk-up apartment in Greenwich Village.

ABOVE: After a carriage ride through Central Park, accompanied by the groovy title song by *Odd Couple* composer Neal Hefti, Paul and Corie Bratter (Robert Redford and Jane Fonda) prepare to cross the threshold of the Plaza for their honeymoon.

OPPOSITE BOTTOM: Gene Saks on set with Fonda and Redford. Saks took over the directorial duties from Mike Nichols, who had staged the original Broadway version of *Barefoot*. Saks would go on to succeed Nichols on the movie version of Simon's next smash, *The Odd Couple*, the following year.

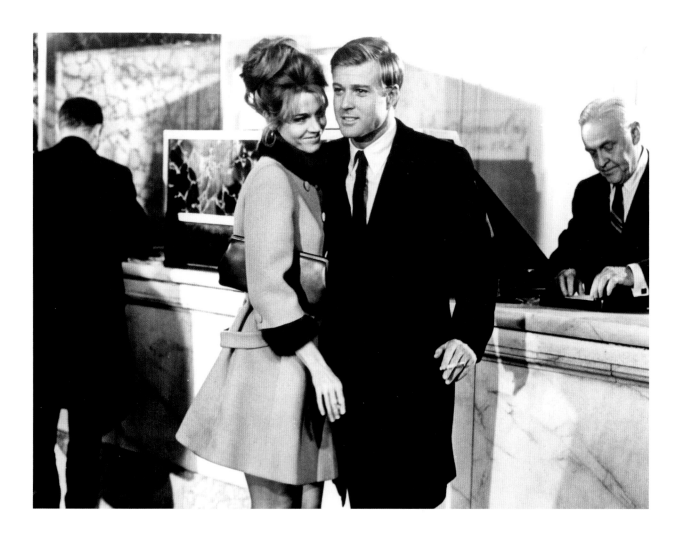

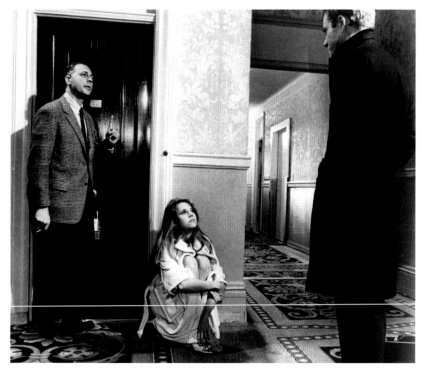

ABOVE: Redford recreated the role he played on Broadway, but his leading lady, Elizabeth Ashley—apparently not considered a sufficient box-office draw—was replaced by Jane Fonda after Natalie Wood turned the part down. Perhaps Wood was tired of working with her good friend Redford (if such a thing is even possible) after filming two other movies with him: *Inside Daisy Clover* and *This Property is Condemned*.

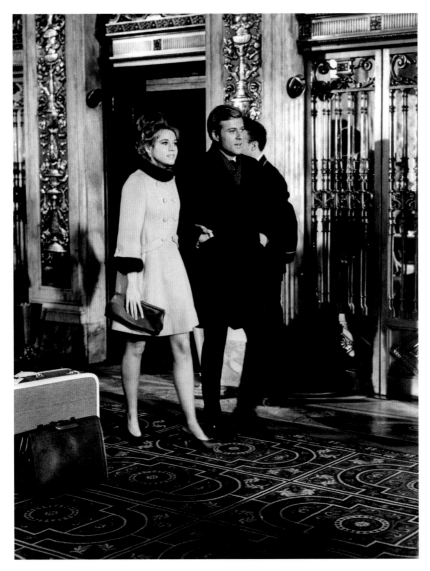

Fonda and Redford stroll through the lobby of the Plaza, back in the days when the prospect of a "honeymoon night" could be counted on to raise a titter in the audience. Fonda's powder-blue, fur-trimmed coat was designed by the legendary Edith Head.

BELLBOY: How long they been in there?

CHAMBERMAID: Five days.

BELLBOY: That must be a hotel record.

CHAMBERMAID: For a political convention. Honeymoon record's nine days.

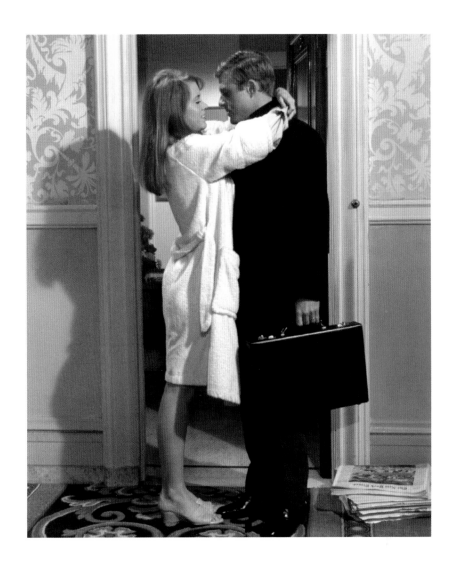

ABOVE: Corie tries to convince Paul to stay one more day. His response? "I can't kiss you anymore. My lips are numb!" Note the stack of newspapers outside the door, a sly wink at the newlyweds' stamina.

RIGHT: Redford and Fonda with producer Hal Wallis, once a titan at Warner Brothers and the "studio suit" behind such classics as *Casablanca*; *Yankee Doodle Dandy*; and *Now, Voyager*.

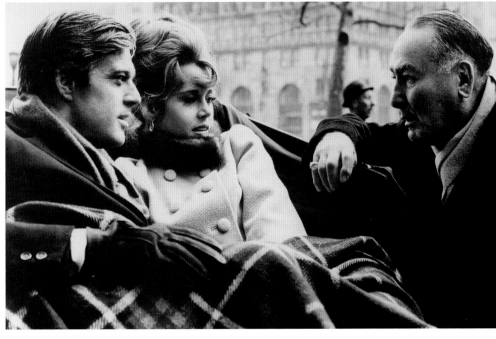

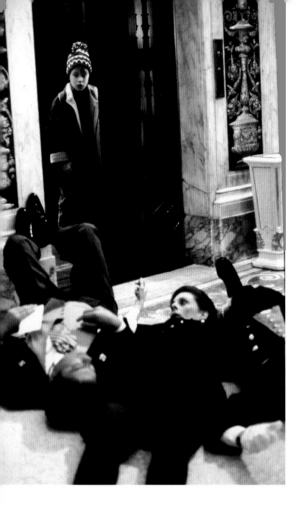

HOME ALONE 2: LOST IN NEW YORK

Directed by Chris Columbus
Screenplay by John Hughes
Released in 1992

The bumbling burglars from *Home Alone* are still after young Kevin, this time in New York City.

LEFT: Wreaking havoc without ever losing his angelic demeanor, Macaulay Culkin leaves Tim Curry, Dana Ivey, and Rob Schneider—playing the hapless staff of the Plaza—in a slapstick heap.

BELOW: Resembling nothing less than a cross between Shirley Temple and Dennis the Menace, little Kevin McCallister gets stranded on his own. Again.

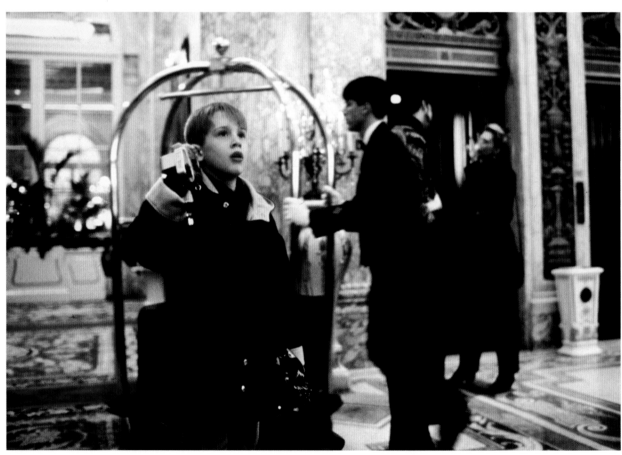

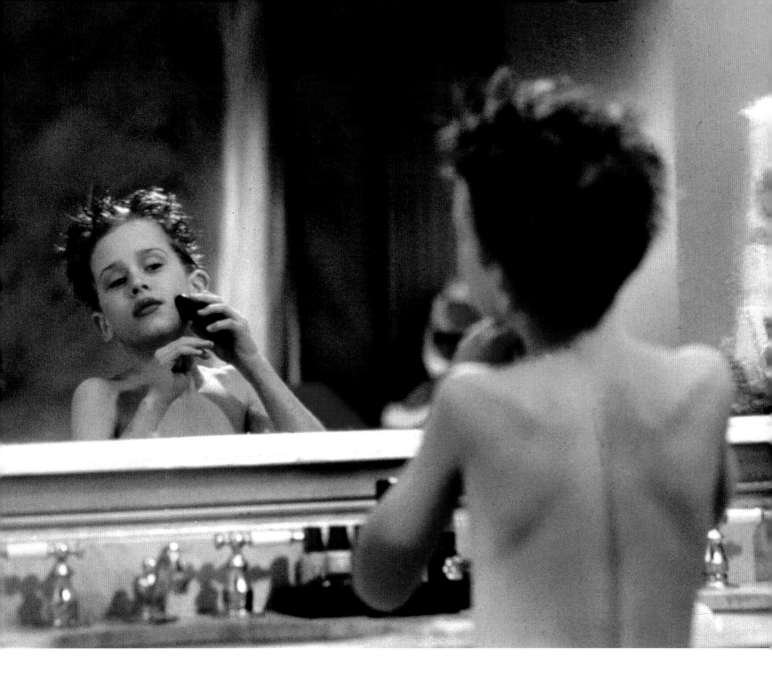

ABOVE: Culkin is two years older than he was in the original film, so reprising his beloved mirror monologue called for a little twist. This time, he's shaving.

RIGHT: Director Chris Columbus, screenwriter John Hughes, and producer Richard Vane on location in front of the Plaza.

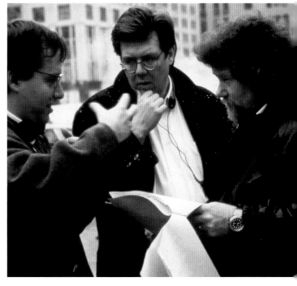

KATE MCCALLISTER: What kind of idiots do you have working here?
DESK CLERK: The finest in New York.

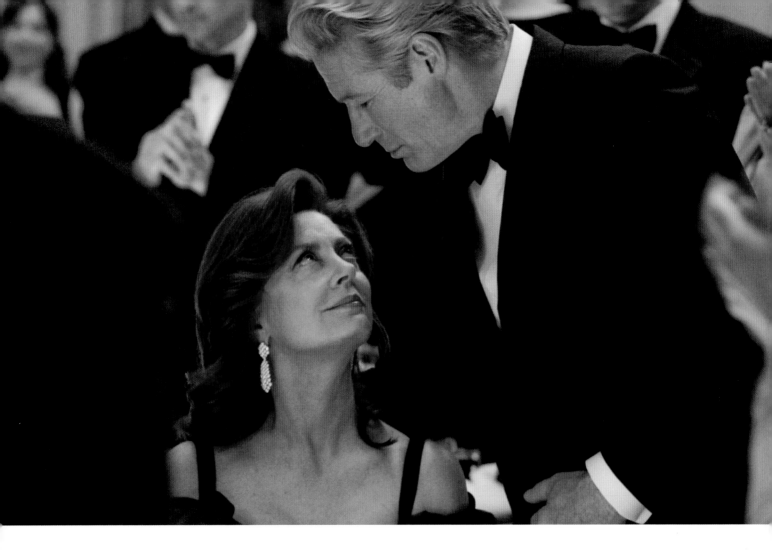

ARBITRAGE

Directed by Nicholas Jarecki
Screenplay by Nicholas Jarecki
Released in 2012

A successful hedge fund manager's business and personal life begin to unravel as his family's buried secrets come to light.

ROBERT MILLER: This is a trust, in your name, assets of two million dollars. Take a look at that.
JIMMY GRANT: Are you serious? You think money's gonna fix this? Huh?
ROBERT MILLER: What else is there?

Susan Sarandon and Richard Gere in one of the climactic scenes of the thriller, filmed in the Grand Ballroom of the Plaza. The fact that it could actually be shot in the Plaza was a shock to producer Kevin Turan, considering the movie's modest twelve-million-dollar budget: "I thought we'd be in a banquet hall in Long Island, but it's another testament to our director, who wouldn't compromise on any level, so we ended up shooting in the Plaza."

AMERICAN HUSTLE

Directed by David O. Russell
Screenplay by Eric Warren Singer, David O. Russell
Released in 2012

In this caper based on the true story of "Abscam," a brilliant con man and his beautiful partner find themselves working with the FBI's wildest agent to penetrate the volatile world of New Jersey organized crime.

RIGHT: Bradley Cooper adjusts Christian Bale's comb-over in a scene from the very black comedy inspired by an FBI sting operation of the 1970s.

BELOW: Bradley Cooper, Jeremy Renner, Charlie Broderick, and Christian Bale engage in some dirty dealings. Exterior shots of the Plaza were filmed, but, as the facade of the hotel was surrounded by scaffolding, CGI artists had to erase all evidence of the construction work.

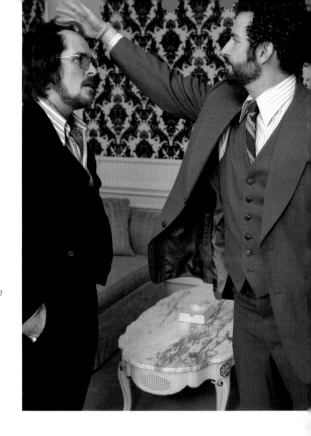

RICHIE DIMASO: What are you doing, going behind my back? Telling people I'm screwing up this operation? I got you a suite at the fucking Plaza Hotel.
IRVING ROSENFELD: The shittiest suite at the Plaza Hotel.

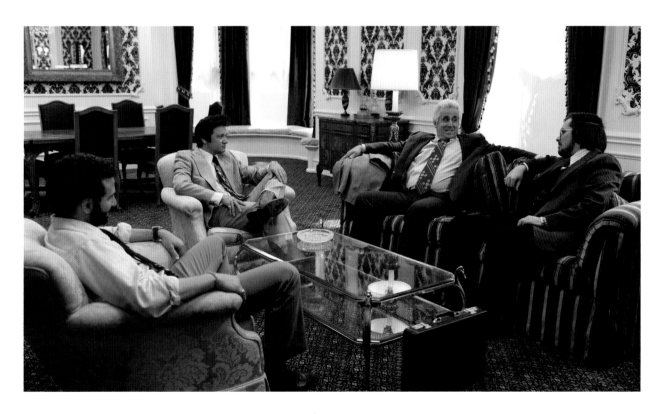

ARTHUR

Directed by Steve Gordon
Screenplay by Steve Gordon
Released in 1981

A reckless, drunken millionaire—a kind-hearted mess—is a constant embarrassment to his powerful British family. When his infatuation with a thief interferes with plans to marry him off to someone more suitable, Arthur seeks the counsel of his steadfast and sensible butler.

After twenty years of pairing with Peter Cook as one of England's most famous comic duos, Dudley Moore's turn as the lovable millionaire tippler Arthur Bach instantly turned him into a full-fledged movie star.

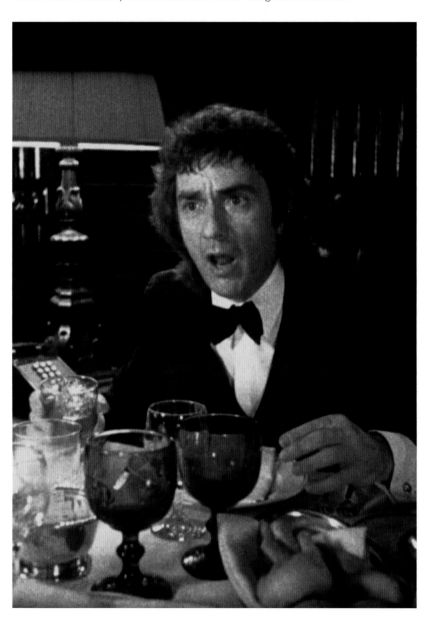

ARTHUR: Hobson?

HOBSON: Yes.

ARTHUR: Do you know what I'm going to do?

HOBSON: No, I don't.

ARTHUR: I'm going to take a bath.

HOBSON: I'll alert the media.

ARTHUR: Do you want to run my bath for me?

HOBSON: That's what I live for.

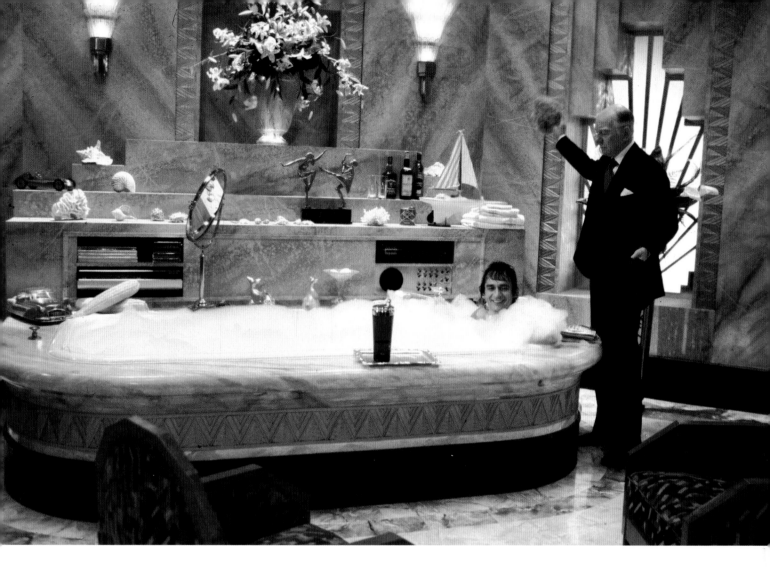

ABOVE: In the most beloved scene from the film, Arthur takes a bath in his deluxe suite at the Plaza, attended by his relentlessly deadpan, acid-tongued valet, Hobson (John Gielgud). Of course, no such bathroom exists at the Plaza, but that hasn't stopped guests at the hotel from asking to stay in the "Arthur Suite."

RIGHT: When Arthur spies Linda Marolla (Liza Minnelli) pinching a tie at Bergdorf Goodman, love strikes and the eternal Peter Pan starts to grow up.

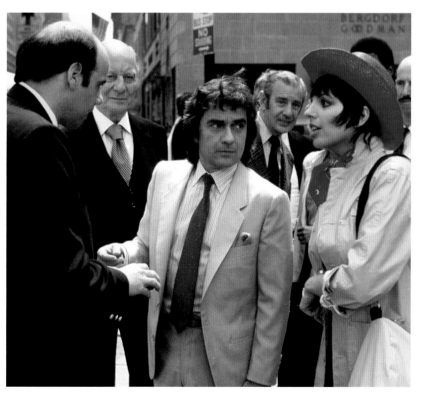

NORTH BY NORTHWEST

Directed by Alfred Hitchcock
Screenplay by Ernest Lehman
Released 1959

This classic Hitchcock thriller follows an innocent man as he is pursued across the country by anti-government agents who believe he is trying to foil their plot to steal national secrets.

RIGHT: Cary Grant and Alfred Hitchcock on location outside the Plaza.

BELOW: It may look like the Oak Room, but chalk that up to Hollywood sorcery: It's really just an expert recreation on the MGM lot. Has anyone ever looked better with a martini in front of him than Cary Grant?

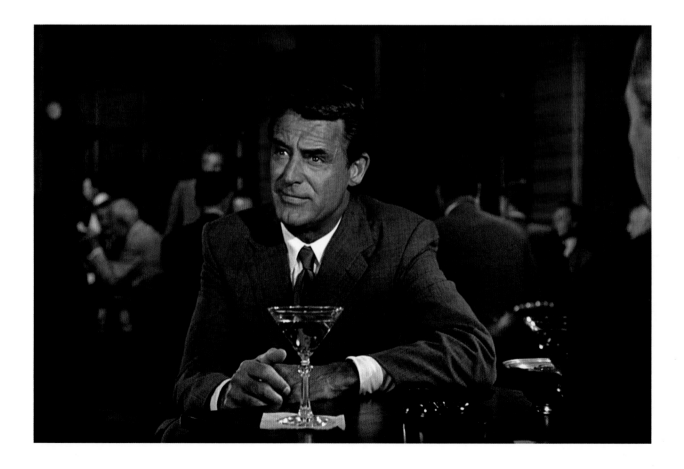

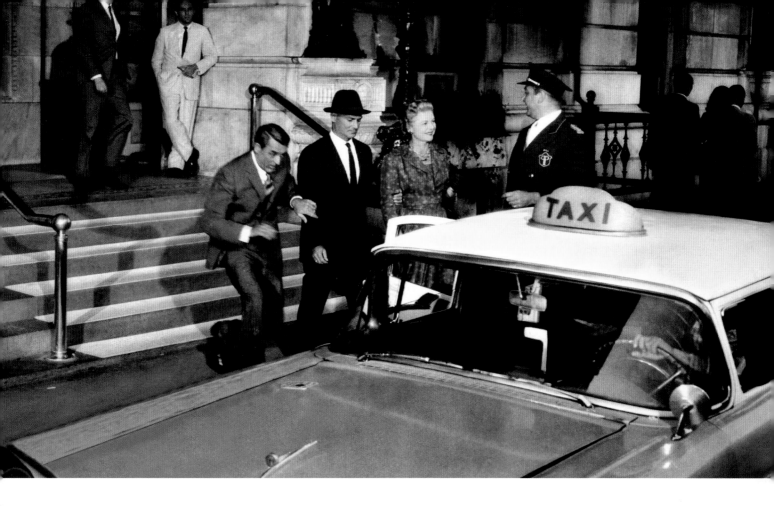

ABOVE: Roger Thornhill (Cary Grant) makes a break for it and sets off on a trek that will eventually leave him (and the audience) hanging from Mount Rushmore.

LEFT: "You gentlemen aren't REALLY trying to kill my son, are you?" Jessie Royce Landis, Cary Grant, Allen Williams, and Robert Ellenstein share an elevator at the Plaza in a trademark Hitchcock specialty: the comic suspense scene.

ROGER THORNHILL: Now you listen to me, I'm an advertising man, not a red herring. I've got a job, a secretary, a mother, two ex-wives, and several bartenders that depend upon me, and I don't intend to disappoint them all by getting myself "slightly" killed.

Two shots of Roger Thornhill walking through the lobby and into the Oak Room. Cary Grant was living in a suite at the hotel while filming the movie's location shots, and it wasn't long before crowd control became an issue. To keep a lid on things, Grant would stay in his room until the very moment the cameras were ready to capture "everyman" Thornhill.

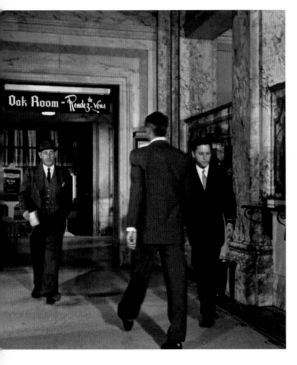

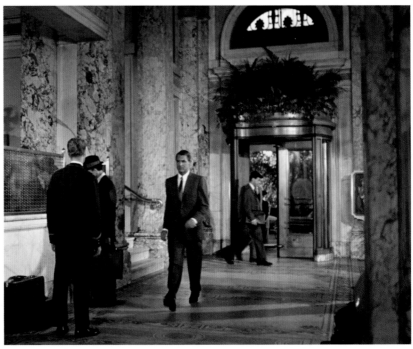

RIGHT: Cary Grant and Jessie Royce Landis as an eternally bemused mother and her increasingly desperate son. The two were only seven years apart in real life.

BELOW: *North by Northwest* was the first movie to actually film scenes inside the Plaza, and the first color movie to film outside of it. (*Gentleman's Agreement* (1947)) had filmed black-and-white exteriors; the Plaza scene in *The Bandwagon* (1953) was entirely a matter of movie magic.)

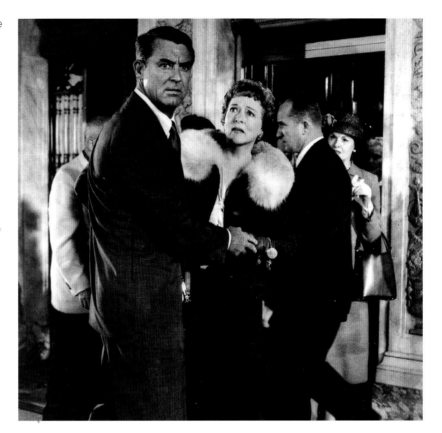

THE GREAT GATSBY

Directed by Jack Clayton
Screenplay by Francis Ford Coppola
Released in 1974

In this F. Scott Fitzgerald classic, young Nick Carraway finds himself fascinated by his wealthy and profligate neighbor, Jay Gatsby, and by Gatsby's own obsession with his lost love.

RIGHT: Alan Ladd and Betty Field as Jay Gatsby and Daisy Buchanan in the 1949 Paramount Pictures adaptation.

BELOW: Hale Hamilton and Lois Wilson as Tom and Daisy Buchanan in the 1926 silent version of *Gatsby*. This film, like so many others of its era, is now lost.

OPPOSITE: Mia Farrow and Robert Redford in the first color adaptation of Fitzgerald's novel. The beautiful costume design, so important to the period detail of the film, is by the Broadway legend Theoni V. Aldredge.

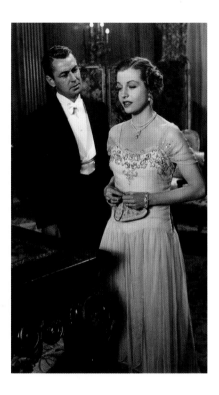

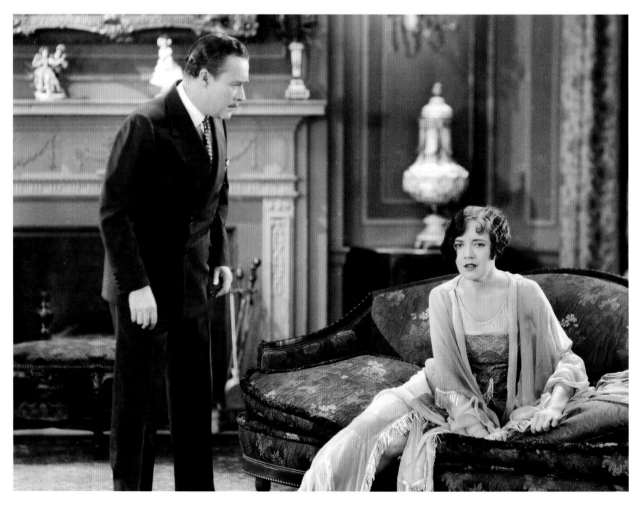

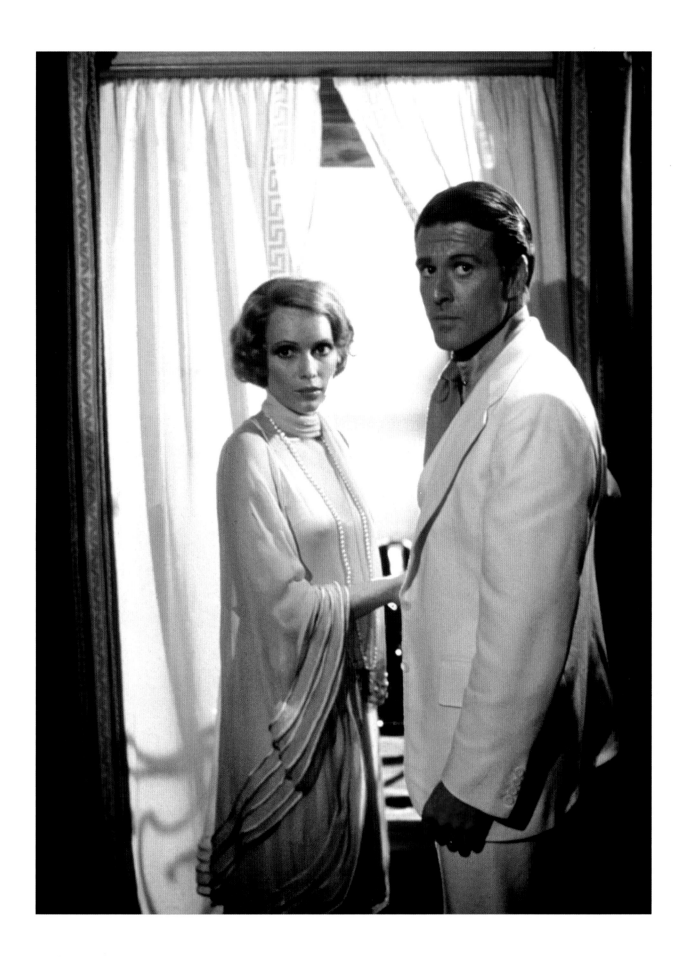

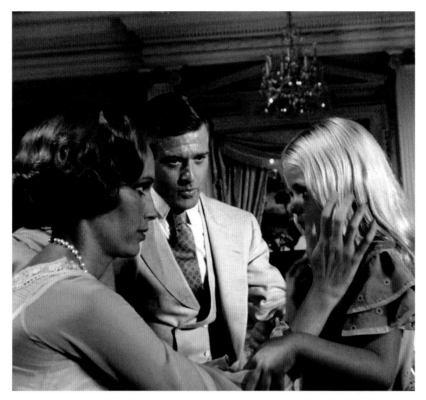

LEFT: Mia Farrow and Robert Redford, as Tom and Daisy, are joined by a six-year-old Patsy Kensit as their daughter Pamela.

BELOW: Bruce Dern, Mia Farrow, and Robert Redford bring to life one of the most tragic love triangles of twentieth-century literature.

OPPOSITE ABOVE: Leonardo DiCaprio and Carey Mulligan in director Baz Luhrmann's 2013 extravagant reimagining of *Gatsby.*

OPPOSITE BOTTOM: Our most recent Daisy Buchanan (Carey Mulligan) in her suite at the Plaza.

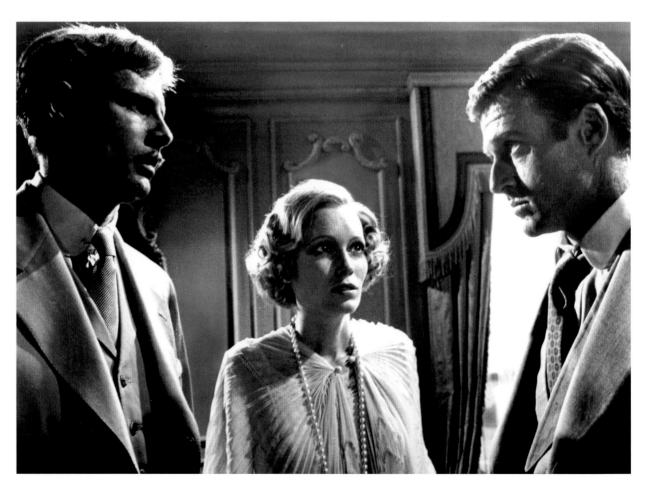

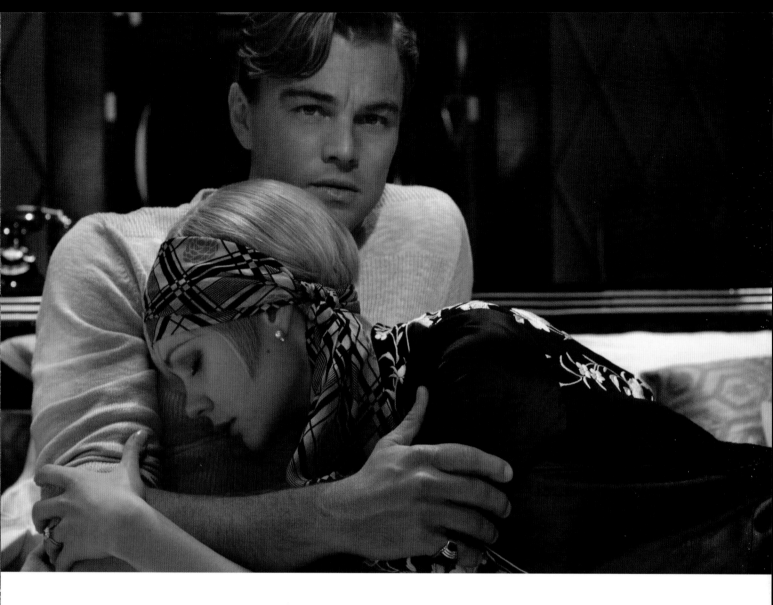

NICK CARRAWAY: I believe that few people were actually invited to these parties. They just went. They got into automobiles that bore them out to Long Island, and somehow they ended up at Gatsby's door. Come for the party with a simplicity of heart—that was its own ticket of admission.

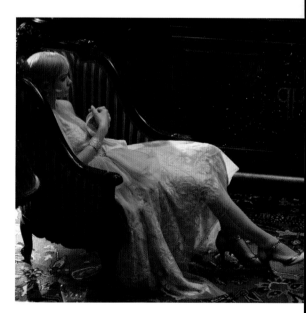

The Plaza on TV

Gossip Girl & That Girl

What girl could resist falling in love outside the Plaza?

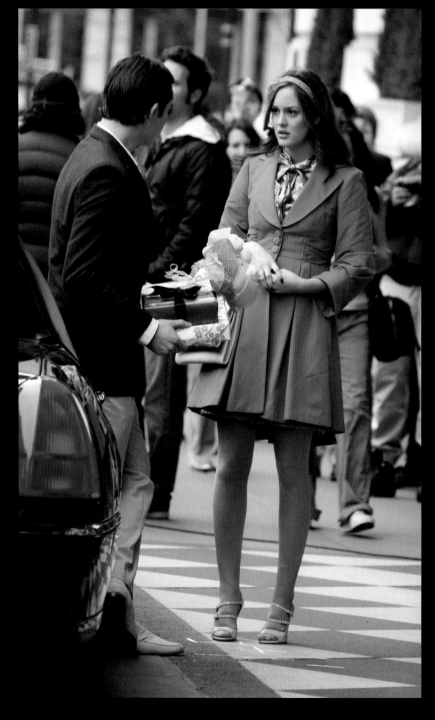

LEFT: New York's most romantic hotel has been featured in two iconic television series, set forty years apart. On *Gossip Girl* (2007-12), one of the most popular series to air on the CW network, Chuck (Ed Westwick) finally confessed his love for Blair (Leighton Meester) in the fan-pleasing second-season finale.

OPPOSITE: On *That Girl* (1966-71), Marlo Thomas played aspiring actress Ann Marie, who made the arduous sixty-mile Metro North journey from Brewster, New York, with dreams of conquering the Great White Way. Here, unemployed yet somehow able to afford a wardrobe by legendary designer Daniel Werle, Ann walks her terrier (who never appeared in the series) out of the 59th Street entrance of the Plaza in an early publicity shot.

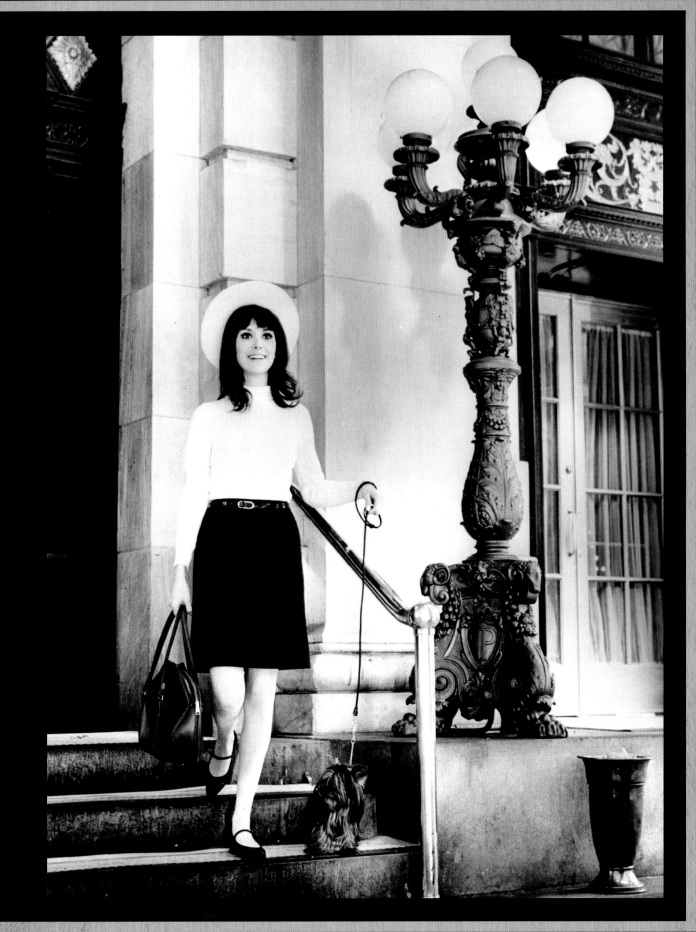

CROCODILE DUNDEE

Directed by Peter Faiman
Screenplay by Ken Shadie, John Cornell, and Paul Hogan
Released in 1986

An eccentric Australian crocodile hunter survives an attack and attracts an invitation to New York—his first time in a big city—by a female journalist.

RICHARD MASON: New York City, Mr. Dundee. Home to seven million people.

CROCODILE DUNDEE: That's incredible. Imagine seven million people all wanting to live together. Yeah, New York must be the friendliest place on earth.

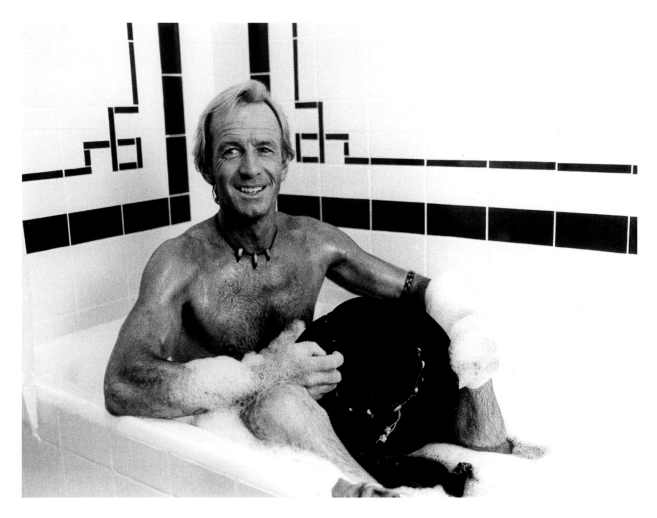

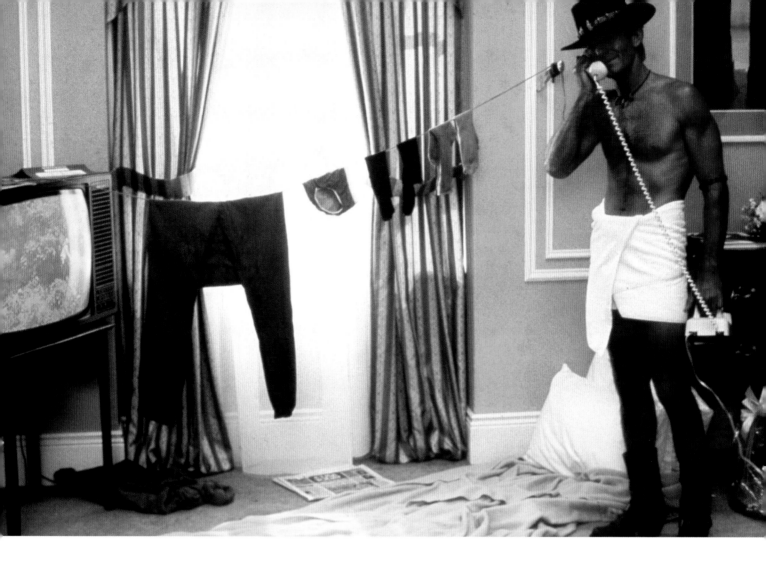

OPPOSITE: Paul Hogan's bathtub scene made the ladies swoon, but his comic encounter with a bidet was the stuff of fiction—no such luxury exists at the hotel. That hasn't deterred legions of Plaza guests from asking the front desk why their room doesn't have one of "those contraptions."

ABOVE: Although the Plaza prides itself on its one-day laundry service, "Crocodile" was determined to rough it. Plus, it gave him a chance to walk around in a towel.

RIGHT: What is it about the Plaza that inspires romance? Real-life love blossomed on the set of *Crocodile Dundee*, and costars Paul Hogan and Linda Kozlowski (here in front of the Pulitzer fountain during filming) were married for almost twenty-four years, until their divorce in 2014.

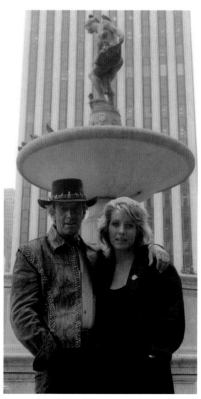

NO LIMIT

Directed by Frank Tuttle
Screenplay by Salisbury Field and Viola Brothers Shore
Released in 1931

When an irrepressible theater usherette agrees to apartment sit for a friend, she gets more than she bargained for: It turns out the place is an illegal gambling parlor. On the plus side, she meets the man of her dreams.

RIGHT: Clara Bow, known as the "It Girl" to millions of moviegoers in the 1920s and '30s, revisits her old stomping ground to see best pal Dodo Potter (Dixie Lee, first wife of Bing Crosby). *No Limit* was the first sound film ever shot in New York City, and includes exciting scenes of Bow running to catch the Sixth Avenue "El" train, and location footage shot at the Plaza.

BELOW: Bunny and her beloved scoundrel DT (Norman Foster, who was married at the time to movie legend Claudette Colbert). As this was a Pre-Hollywood Production Code film, a couple could actually share a bed without a sheet hanging between them or one foot on the floor.

BUNNY: Dodo, that's him!
DODO: Who?
BUNNY: DT! Isn't he grand?
DODO: Yeah!

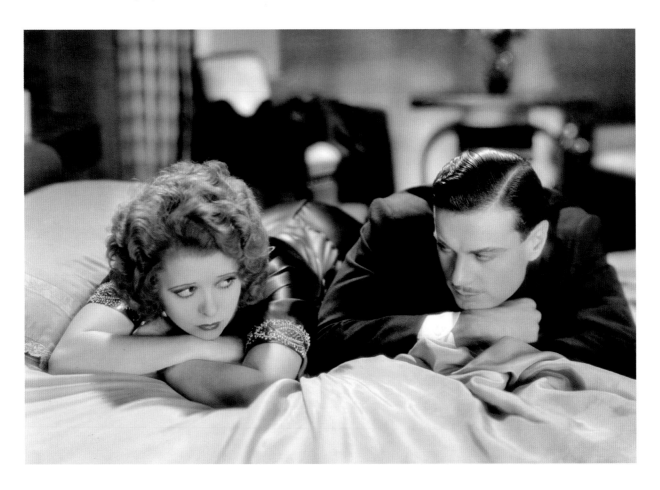

THE ROSE

Directed by Mark Rydell
Screenplay by Bo Goldman and Bill Kerby
Released 1979

This musical biopic based loosely on the story of Janis Joplin follows a self-destructive 1960s rock star struggling to cope with the pressures of her career and the demands of her ruthless manager.

RIGHT AND BELOW: Bette Midler as self destructive singer Rose Foster and Frederic Forrest as her chauffeur/lover Huston Dyer return to the Plaza after a night of partying New York-style.

"Look at the place… LOOK AT THIS PLACE!" says Rose to Huston. "I'm rich y'know… I'd buy the whole damn place if I wanted to." In response, Huston tells her about a six-day solo adventure he had on the Little Bighorn River, at which point she looks at him with utter disbelief and weariness and whispers, "Were you really alone for six days?"

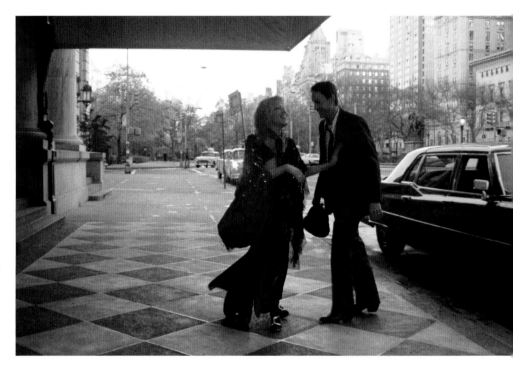

ROSE: What are we ladies? What are we? We are waitresses at the banquet of life!

KING OF NEW YORK

Directed by Abel Ferrara
Screenplay by Nicholas St. John
Released in 1990

Kingpin Frank White returns to New York after a long stretch in prison, intent
on re-establishing his drug empire. Not surprisingly, his enemies on both sides
of the law have other plans.

FRANK WHITE: You think ambushing me in some
nightclub's gonna stop what makes people take
drugs? This country spends $100 billion a year on
getting high, and it's not because of me. All that
time I was wasting in jail, it just got worse. I'm not
your problem. I'm just a businessman.

OPPOSITE: Jimmy Jump (Larry Fishburne) visits Frank White (Christopher Walken) in his palatial Plaza suite. His "welcome home from Sing Sing" gift is the news that he has eliminated a rival Columbian drug dealer. "I feel no remorse," Frank replies. As Jimmy is leaving, Frank asks him why he never visited him in prison. "I didn't want to see you in a cage," he says.

RIGHT: What could be better after a stretch in the joint than a stay at the Plaza? The addition of good caviar and expensive champagne is sure to spark a few brainstorms about how to get revenge on the cops and rival drug lords that sent you away in the first place.

BELOW: Frank's attorney and lover, Jennifer (Janet Julian), informs him that Jimmy has been arrested and the cops are quickly closing in. "I want that cop Bishop's brains blown all over his wingtips," Frank responds.

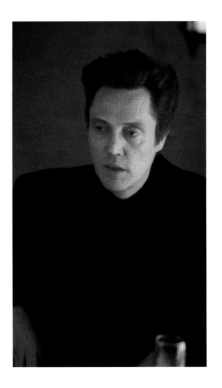

Plaza Pretenders

Is it real or is it…Hollywood? While screenwriters and directors *love* the idea of filming on location at the Plaza—who wouldn't?—producers and studios sometimes get a little cranky about the cost. No budget for location filming in New York? No problem! Savvy production designers can recreate just about anything, from the Oval Office to the surface of the Moon. Why not the lobby, elevators, and porticos of the Plaza? Here are just a couple of examples of *faux* Plaza scenes. Others appear throughout the book, but we've blown the whistle in every case. No matter—these scenes still exude that Plaza magic.

BELOW: Lily Tomlin/Bette Midler/ Bette Midler/Lily Tomlin as two sets of twins separated at birth in the 1988 romp *Big Business*. Filming inside the Plaza proved to be too expensive, so the entire hotel lobby was recreated at MGM and later reused in the flop Mel Brooks sitcom *Nutt House*, starring Cloris Leachman and Harvey Korman.

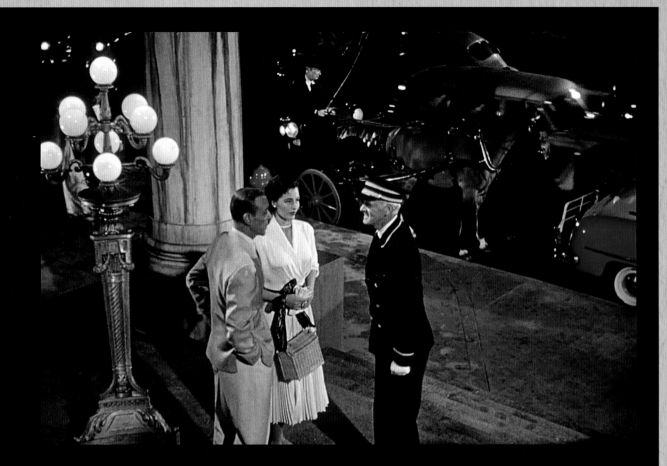

ABOVE: A very believable rendition of the Plaza was created by the genius production designers at MGM for the 1953 movie *The Band Wagon*. By the time Fred Astaire and Cyd Charisse got to Central Park and began "Dancing in the Dark," savvy audiences had figured out they were looking at a sound stage (no muggers, for one thing)—but the dash out of the 59th Street exit and into a hansom carriage was a top-notch example of Hollywood magic.

RIGHT: In Ron Howard's 2005 movie *Cinderella Man*, about the Depression-era boxer James J. Braddock and starring Russell Crowe and Renee Zellweger (here on location with Howard), the Fairmont Royal York Hotel in Toronto was the stand-in for the iconic New York landmark.

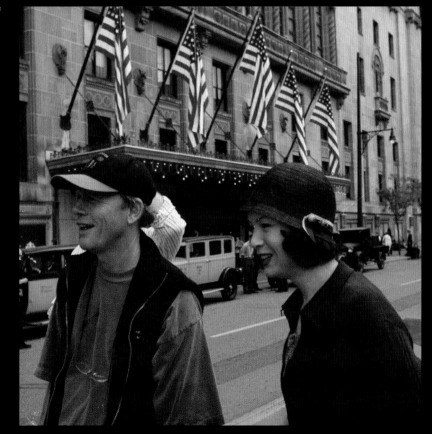

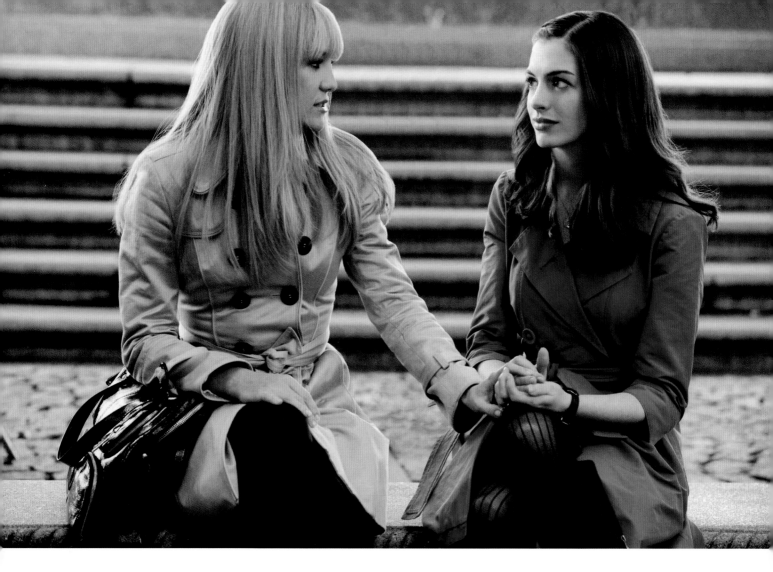

BRIDE WARS

Directed by Gary Winick
Screenplay by Greg DePaul, Casey Wilson, and June Diane Raphael
Released in 2009

Best friends become fierce competitors when they schedule their weddings on
the same day.

MARION: A wedding marks the first day of the rest of
 your life. You have been dead until now. Were you
 aware of that? You're dead right now.
EMMA: I understand.
MARION: Angela, for example, will die dead.

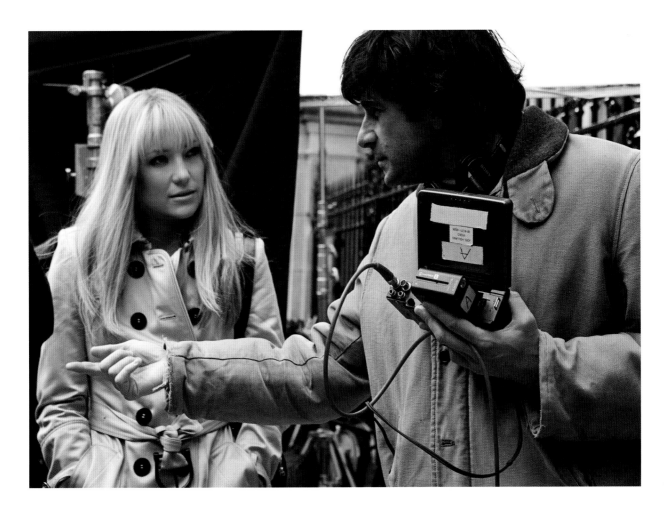

ABOVE: Kate Hudson gets her marching orders from director Gary Winick in preparation for a scene set outside the Plaza.

RIGHT: The battling Bridezillas take a break from filming in front of the hotel while Anne Hathaway takes an important call.

OPPOSITE: Girlfriends since forever, Emma (Anne Hathaway) and Liv (Kate Hudson) commiserate on the steps of the Plaza when they discover their weddings are to take place there on the same day.

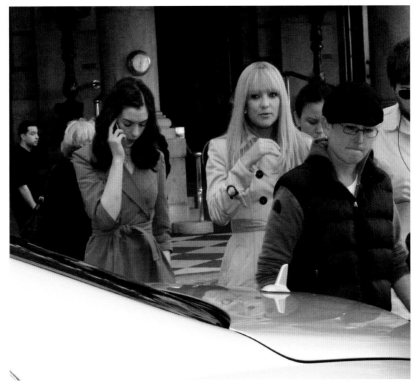

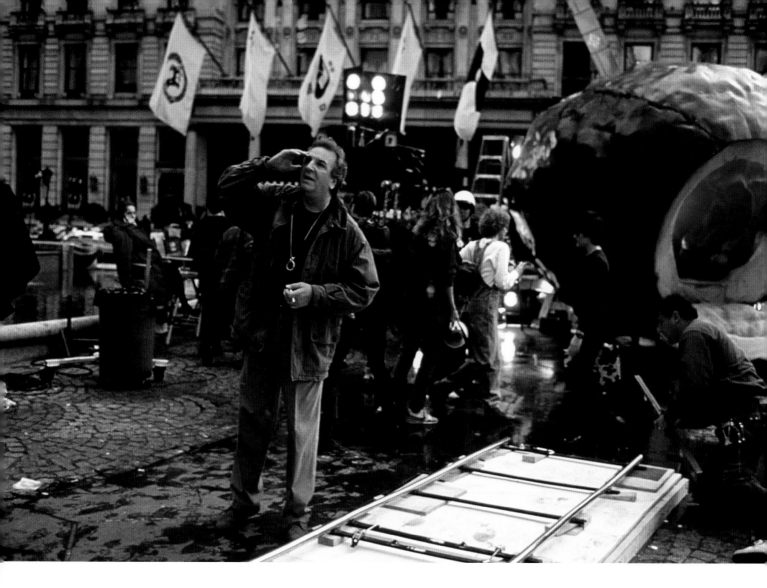

THE PICKLE

Directed by Paul Mazursky
Screenplay by Paul Mazursky
Released in 1993

A well-known film director on a losing streak is forced to helm an outlandish science-fiction spoof in order to pay his tax bill. Will it prove the last nail in his artistic coffin—or become an unlikely hit?

PHIL HIRSCH: The studio called. How many seats do you want for the preview?
HARRY STONE: Zero seats. I don't go to my own funerals.

Danny Aiello as desperate movie director Harry Stone, directing the movie-within-the-movie of *The Pickle*. The plot of the movie-within-the-movie? Farmers from Kansas build a spaceship out of a giant cucumber and land on a planet whose Supreme Leader is Little Richard (playing himself). Their mission is to deliver vegetables to the inhabitants, who eat only beef and all die at the age of 49. If the Plaza were a person, she may well have wanted her "face" disguised in this shot.

EDDIE

Directed by Steve Rash
Screenplay by Jon Connolly, David Loucka, Eric Champnella, Keith Mitchell, Steve Zacharias, and Jeff Buhai
Released in 1996

Edwina "Eddie" Franklin is a limo driver who loves the New York Knicks passionately, in spite of their current slump. When she wins a contest to become the team's coach, she turns their fortunes around and wins the hearts of the fans.

AL TRAUTWIG: Do you think she can get the team out of the basement?
RUDOLPH Giuliani: She can't do any worse.
EDWARD KOCH: The Knicks were winning when I was mayor.

Frank Langella on location outside the Plaza. In another example of Plaza love potion, Langella and Whoopi Goldberg began a romance during filming, which blossomed into a five-year relationship.

Music Plaza-Style

Mariah Carey

The Plaza was the center of the musical universe for a few days in 1964, when the Fab Four made it their New York headquarters. It would be a while before the place became synonymous with pop music again.

Enter Mariah Carey in 2009, with the release of her song "Obsessed." The music video that accompanied the infectious pop tune was helmed by movie director Brett Ratner and features Carey playing two characters, herself and her own stalker. The stalker character first appears dressed as a bellman at the Plaza and later, in a gray hoodie and sweatpants, following the "real" Mariah down the street.

The video created a media firestorm when it emerged that the song might be a veiled jab at rapper Eminem, who had stated that the two stars had once been involved romantically—a claim Carey vigorously denied. If the video was meant as a swipe at Eminem, it wasn't a subtle one: It ends with the stalker getting run over by a bus while trying to snap a photo of his idol.

Not to be outdone, Eminem released a retaliatory song titled "The Warning." It's all more than enough to make one nostalgic for the days of "I Want to Hold Your Hand."

The three faces of Mariah Carey in "Obsessed."

LOVE AT FIRST BITE

Directed by Stan Dragoti
Screenplay by Robert Kaufman
Released in 1979

In this spoof of the classic horror genre, Count Dracula is forced out of his castle in Transylvania and moves to New York with his bug-hungry assistant, Renfield, to find a bride.

COUNT DRACULA:
I'm going out for a bite to drink.

George Hamilton, as Count Vladimir Dracula, finds that a visit to the Plaza doesn't suck. Upon seeing the film, the question uppermost in the minds of audiences was, how could a creature who lives by night sport such an *amazing* tan?

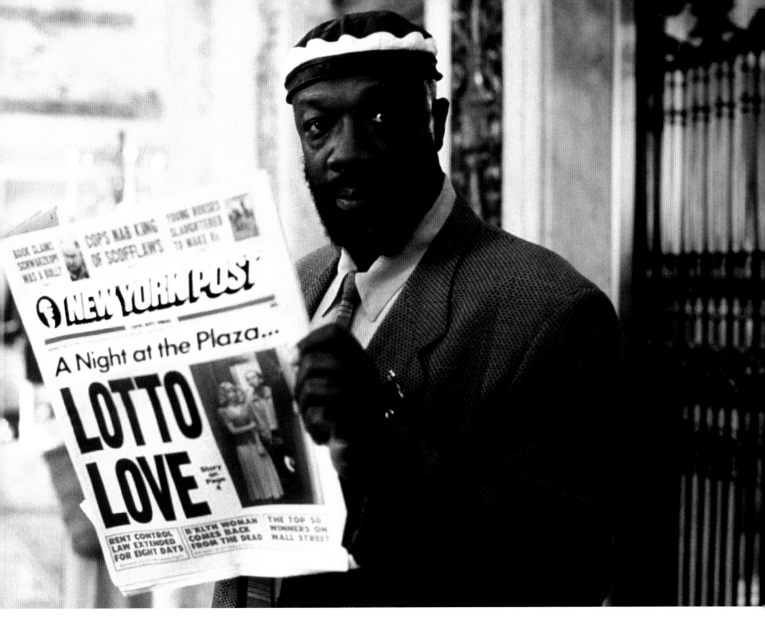

IT COULD HAPPEN TO YOU

Directed by Andrew Bergman
Screenplay by Jane Anderson
Released in 1994

YVONNE BIASI:
Because of
me, you have
nothing.
CHARLIE LANG:
Because of
you, I have you.

A cop named Charlie wins the lottery and feels he must fulfill a prior promise to a diner waitress to share his winnings with her. His wife, however, has other plans—for the money and for their marriage.

ABOVE: Isaac Hayes as reporter and photographer Angel Dupree, the narrator of *It Could Happen to You*. The working title of the film, which is based *ever* so slightly on a real incident, was *Cop Gives Waitress Million-Dollar Tip*. To emphasize its quintessentially New York nature, it is told through a series of *New York Post* headlines.

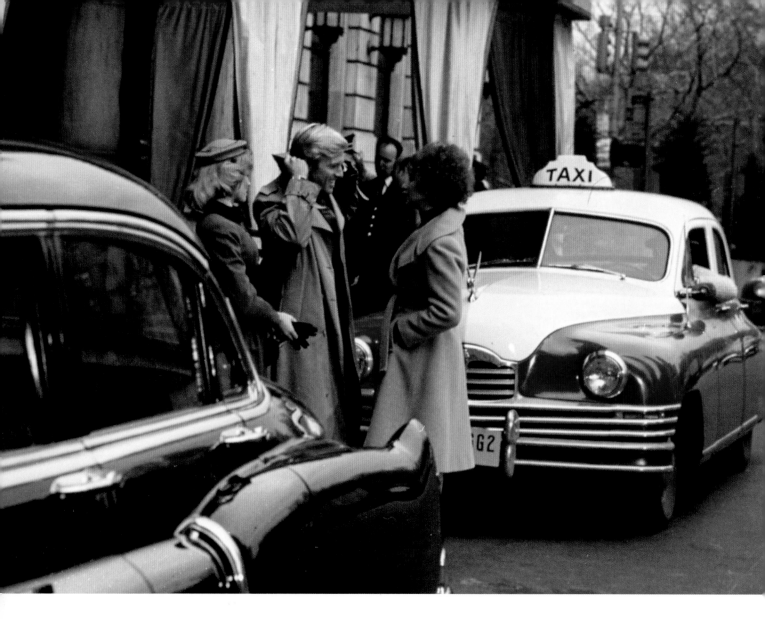

THE WAY WE WERE

Directed by Sydney Pollack
Screenplay by Arthur Laurents
Released in 1973

Hubbell Gardner, a WASP golden boy, and Katie Morosky, a Jewish political firebrand, form the odd couple at the center of this beloved romance that spans the decades of the 1930s, '40s, and '50s.

ABOVE: Perhaps the most famous movie moment ever filmed at the Plaza, the final scene of *The Way We Were* —brilliantly scored by Marvin Hamlisch—earned it its well-deserved "five hanky" rating.

OPPOSITE: Katie and Hubbell (Robert Redford and Barbra Streisand, as if you didn't know) share a rainy, bittersweet moment at the Pulitzer Fountain in a scene ultimately cut from the film.

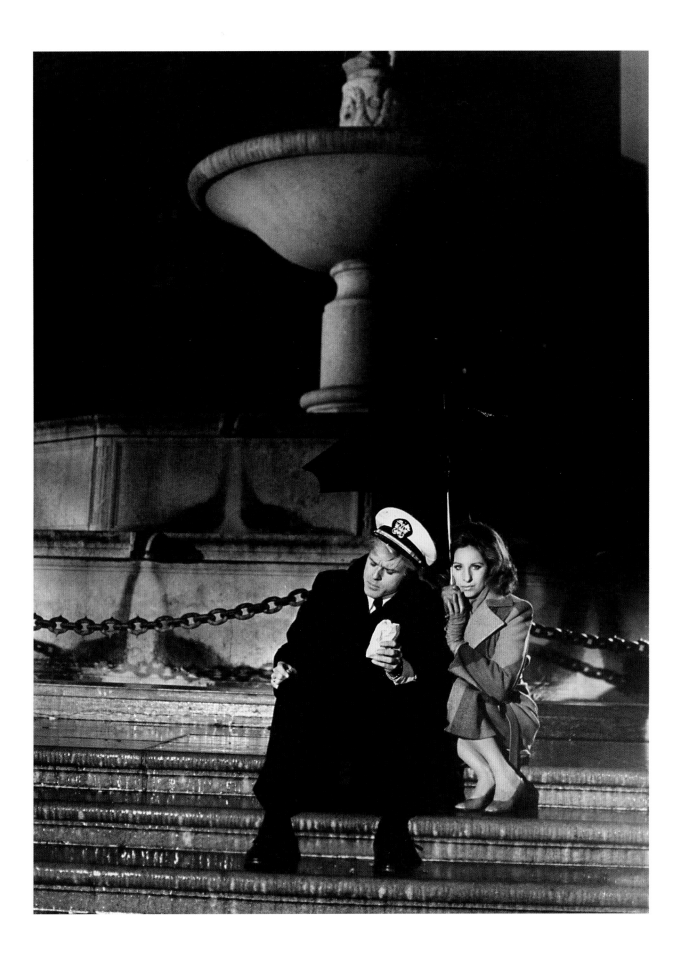

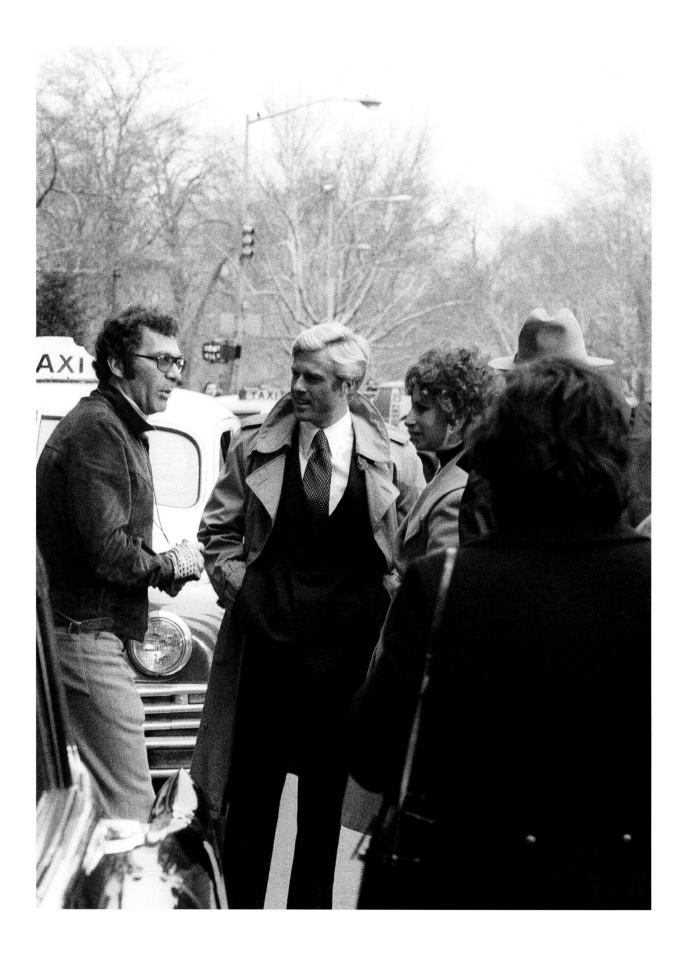

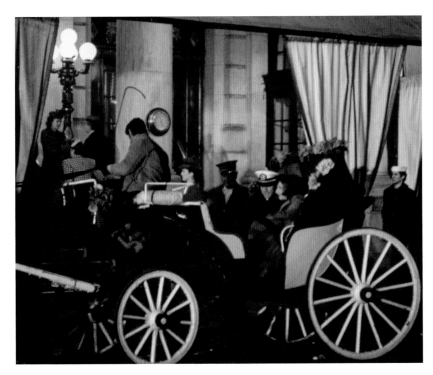

OPPOSITE: Director Sydney Pollock on location with Redford and Streisand.

LEFT: The front of the Plaza becomes a running motif in *The Way We Were*. Here, in their happiest times, the oddly matched lovers end a carriage ride through Central Park.

BELOW: In a rather challenging choice of location, Katie the firebrand hands out fliers in front of the Plaza for an upcoming American/Soviet benefit at Town Hall. As she leaves her post, she grabs an entire stack of fliers from a "Let's do it with Dewey" supporter, walks half a block, and dumps them in a garbage can.

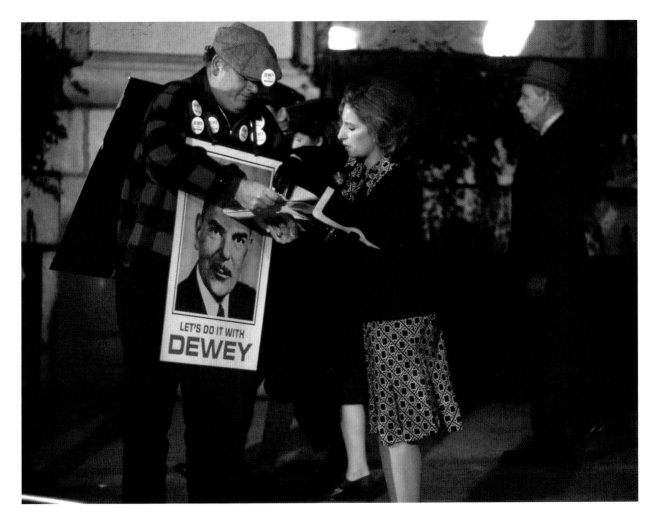

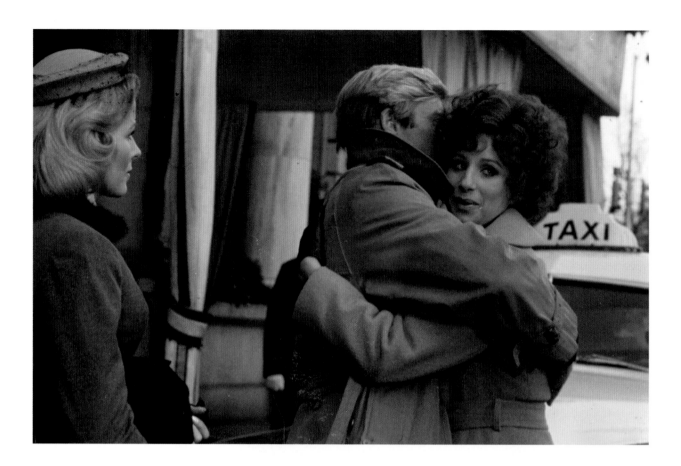

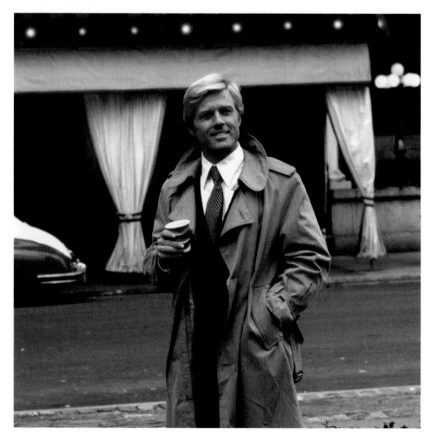

ABOVE: After much water under the bridge, Streisand runs into Hubbell with his slightly bewildered, unnamed "girl"—where else?—in front of the Plaza. Neither of them has changed much: Hubbell is now writing for television and Katie is participating in a "Ban the Bomb" rally.

RIGHT: Robert Redford at the height of his movie-star hunkiness, during location filming of the final scene.

OPPOSITE: Barbra Streisand thinking to herself, "This directing thing looks like a snap! Oh, and Sydney, what if we tried it *this* way…"

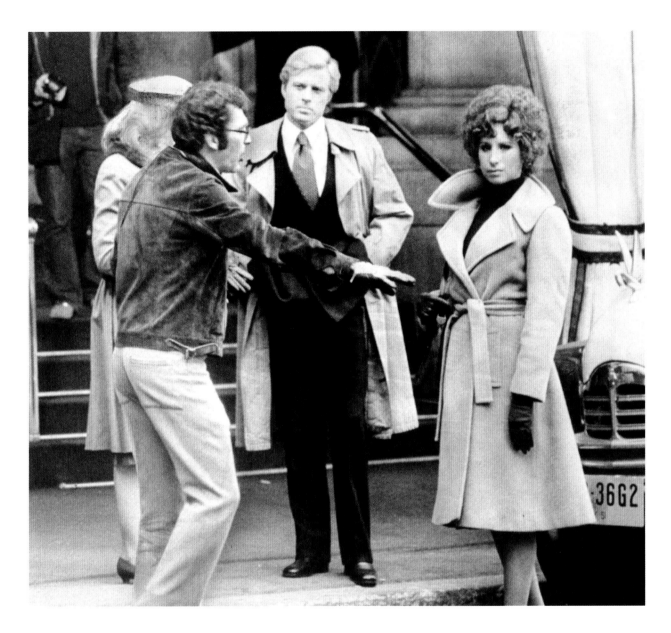

KATIE: If I push too hard it's because I want things to be better, I want us to be better, I want you to be better. Sure, I make waves. I mean, you have to. And I'll keep making them till you're everything you should be and will be. You'll never find anyone as good for you as I am, to believe in you as much as I do, or to love you as much.

HUBBELL: I know that.

The Beatles Plaza-Style

In winter of 1964, the country was still reeling from the assassination of its beloved young President and desperately needed a reason to twist and shout. Enter the Beatles, four mop-topped musicians that hit our shores like a tsunami and went on to become the most popular rock-and-roll band in history. Where else but the Plaza to house these young superstars? For the duration of their New York stay, which included their debut on American TV, the elegant grande dame of New York's gilded age became Beatlemania Central, complete with police barricades to hold back the throngs of screaming teens. When the uproar died down, the Plaza regained her quiet dignity without missing a beat.

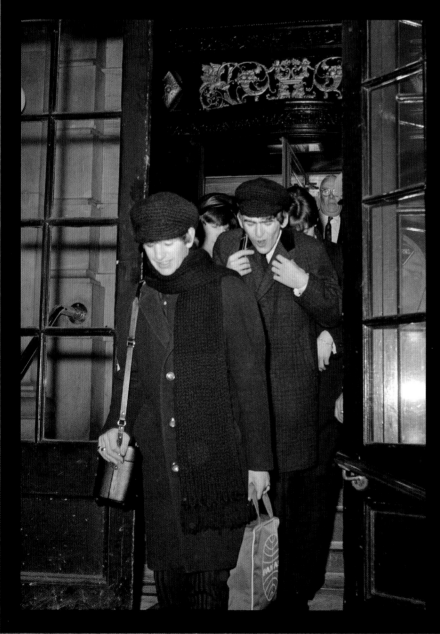

Ringo Starr leads a Beatle exodus from the Plaza to Penn Station on February 11, 1964. The band is en route to its Washington, D.C. debut.

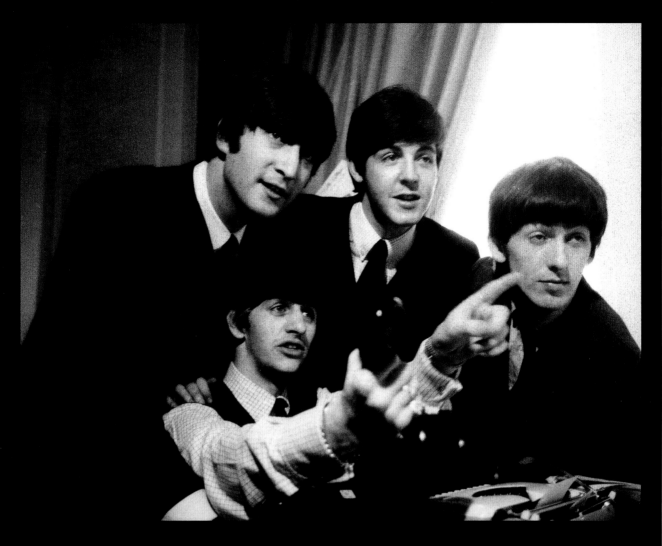

ABOVE: In the midst of a press conference in the Beatles' suite at the Plaza, on February 10, 1964, Ringo innocently takes a phone call that turns out to be from a disc jockey.

RIGHT: Rabid fans rally behind a police line outside the Plaza. The Fab Four are about to make their American television debut on *The Ed Sullivan Show*.

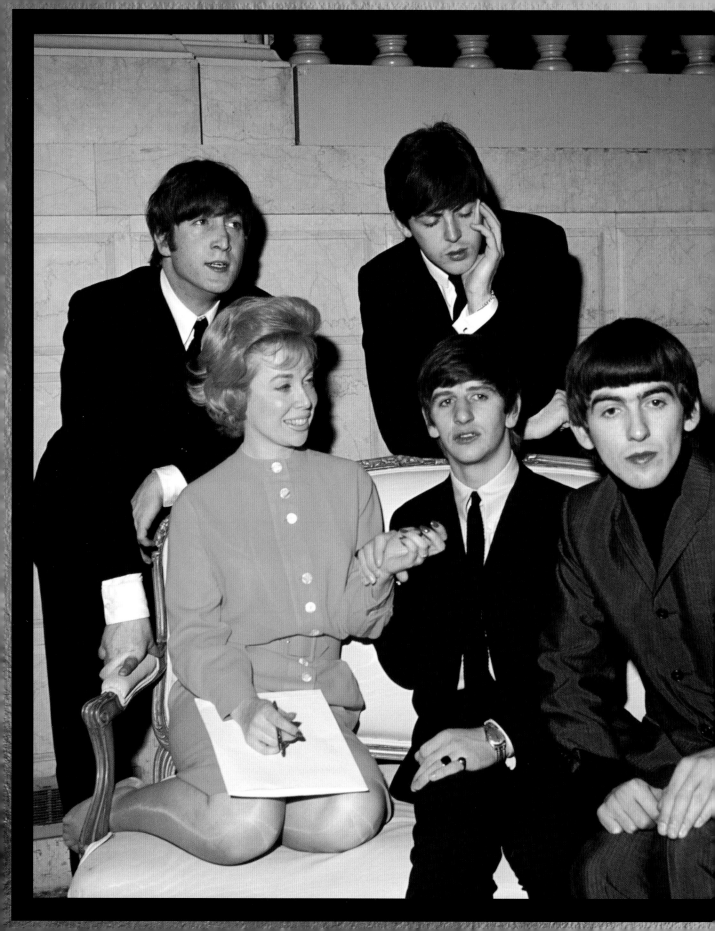

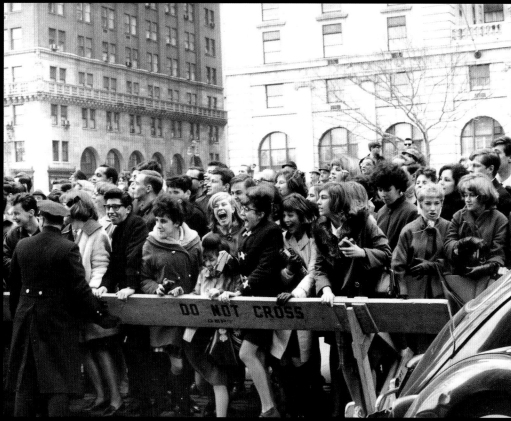

ABOVE: A throng of screaming teenage girls waits outside the Plaza, hoping to get a glimpse of the four lads from Liverpool during their historic first trip to the States.

LEFT: John, Paul, Ringo, and George (you know which is which) surround psychologist (and *$64,000 Question* winner) Dr. Joyce Brothers during an interview.

ELOISE AT THE PLAZA

Directed by Kevin Lima
Screenplay by Janet Brownell
Released in 2003

ELOISE AT CHRISTMASTIME (MADE FOR TV)

Directed by Kevin Lima
Screenplay by Elizabeth Chandler
Released in 2003

ELOISE (MADE FOR TV'S *PLAYHOUSE* 90)

Directed by John Frankenheimer
Screenplay by Leonard Spigelgass
Released in 1956

The adored Eloise picture books by Kay Thompson, with illustrations by Hilary Knight, have been adapted for the small screen several times. They tell the rollicking story of a precocious and independent young resident of the Plaza who spends her days—and holidays—making mischief all over the hotel.

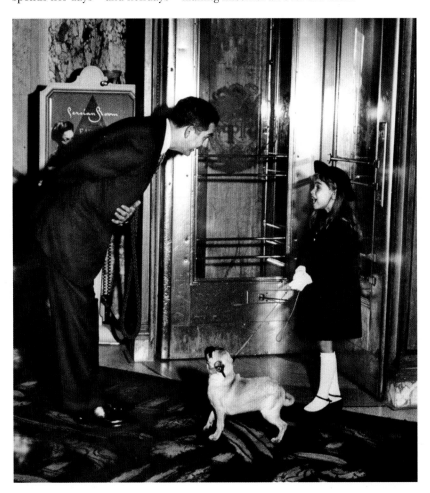

ABOVE AND LEFT: Evelyn Rudie was the luckiest ten-year-old in the world when she was tapped to play the world's most irrepressible Plaza resident. *Life* magazine even devoted space to her, following her around the hotel to illustrate how the fabulous Kay Thompson had created Eloise in the first place. Rumor has it that Ms. Thompson came up with the idea after observing a young Liza Minnelli ordering room service and befriending the staff—but when asked about her inspiration, she coyly replied, "*I* am Eloise."

RIGHT: Julie Andrews and Sofia Vassilieva played Eloise and her long-suffering nanny in the holiday follow-up to *Eloise at the Plaza*, *Eloise at Christmastime*.

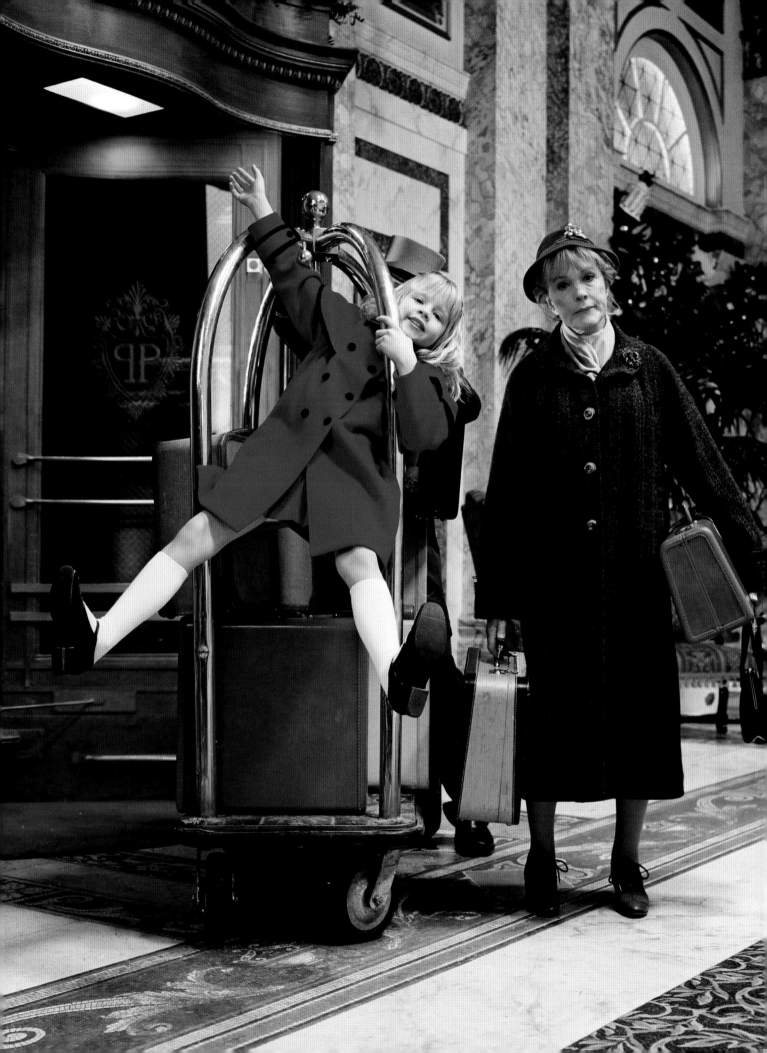

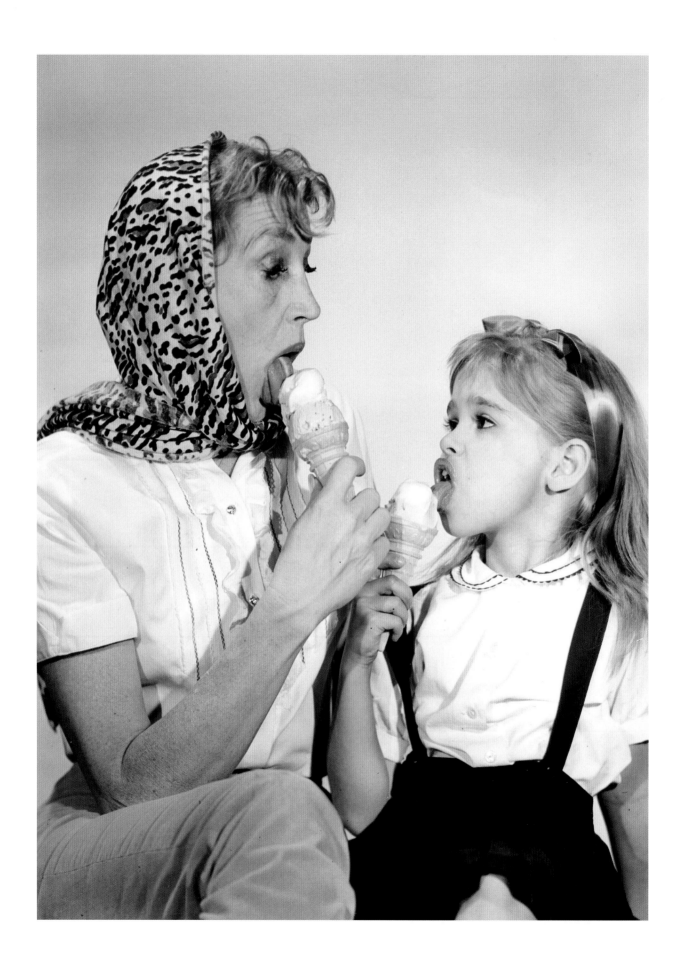

ELOISE: I'm Eloise.
I'm six. I absolutely
LOVE the Plaza.

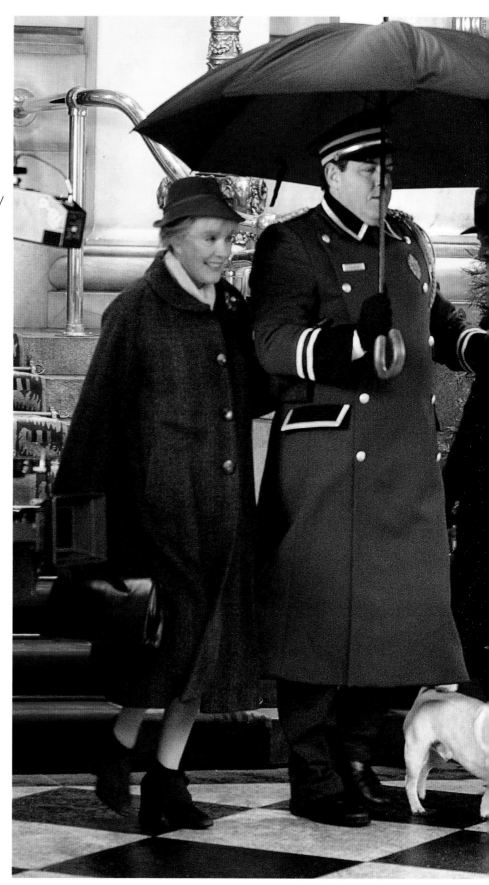

LEFT: The full of "Bazazz" (to use
her own word) Kay Thompson
and Evelyn Rudie in a publicity
shot from the 1956 *Playhouse 90*
special, *Eloise*. From the 1960s
through the 1990s, film actors
considered television "slumming."
But in the 1950s, the finest dramatic
actors from Broadway could be
found on the home screen on a
regular basis. The supporting cast
of the *Eloise* special included
Louis Jourdan, Ethel Barrymore,
Monty Woolley, Hans Conried, and
Mildred Natwick.

RIGHT: Julie Andrews, the eternal
nanny (okay, she did ultimately
get the ring in *The Sound of Music*)
is escorted out of the Plaza during
filming of the first Eloise of the
twenty-first century, the 2003
movie *Eloise at the Plaza*.

The Plaza on TV

When it comes to co-opting the Plaza's iconic elegance, the big screen doesn't have a monopoly. Numerous television shows have ventured to 768 Fifth Avenue to grab a bit of Plaza magic as well.

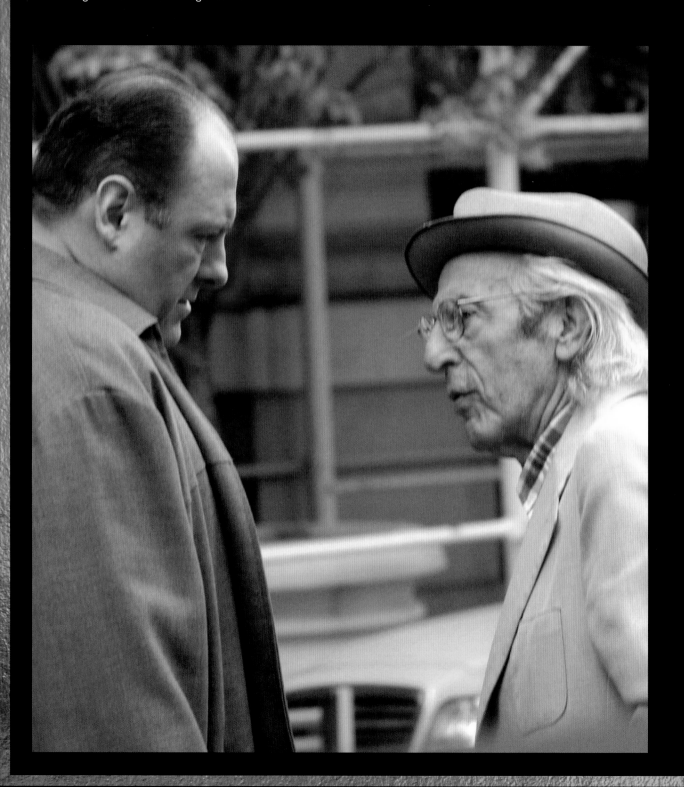

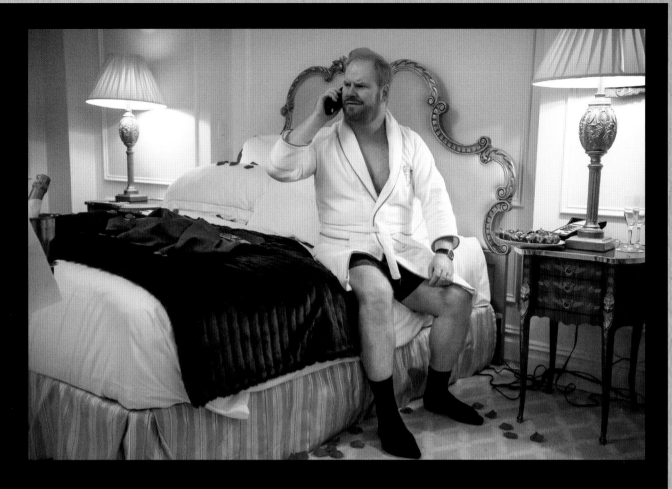

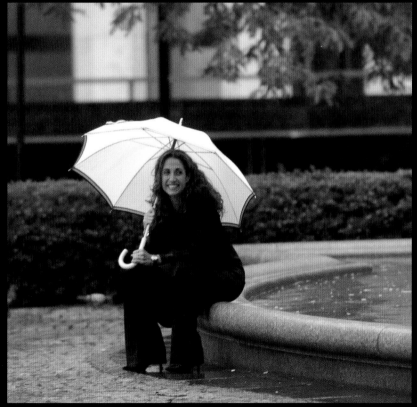

ABOVE: Jim Gaffigan in a 2015 episode of the TV-Land sitcom *The Jim Gaffigan Show* titled "A Night at the Plaza."

LEFT: James Gandolfini filming *The Sopranos* on location in front of the Plaza in October of 2003.

RIGHT: Melina Kanakaredes sits at the Pulitzer Fountain in July of 2004, during location filming for the CBS series *CSI: New York*.

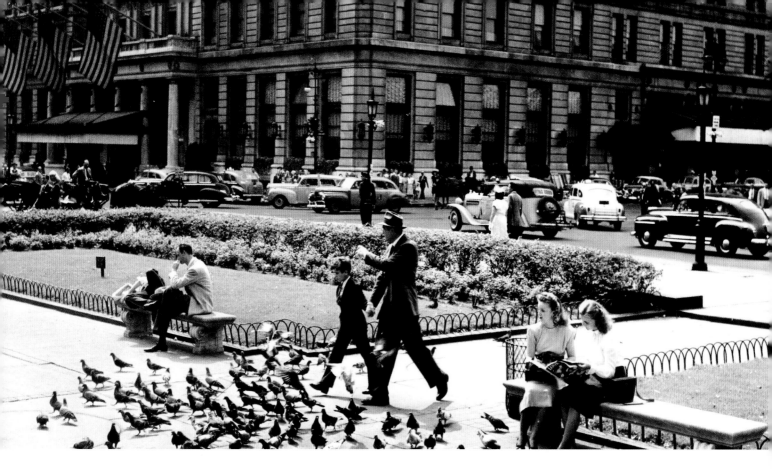

GENTLEMAN'S AGREEMENT

Directed by Elia Kazan
Screenplay by Moss Hart
Released in 1947

Gregory Peck and a ten-year-old
Dean Stockwell cross Grand Army
Plaza in one of the earliest uses of
the Plaza in location filming.

A respected journalist grapples with how to write an exposé of anti-Semitism until
he has brainstorm: He'll go undercover as a Jew and experience things firsthand.
The racism and bigotry to which he is subjected alter his life and relationships.

KATHY LACEY: You think I'm an anti-Semite.

PHIL GREEN: No, I don't. But I've come to see lots
of nice people who hate it and deplore it and
protest their own innocence, then help it along
and wonder why it grows. People who would never
beat up a Jew. People who think anti-Semitism is
far away in some dark place with low-class morons.
That's the biggest discovery I've made. The good
people. The nice people.

SWEET CHARITY

Directed by Bob Fosse
Screenplay by Peter Stone
Released in 1969

Charity Hope Valentine, a taxi dancer with a heart of gold, just wants to be loved. She never stops hoping—in spite of her incessant bad luck—that she'll meet her own Prince Charming and dance off into the sunset.

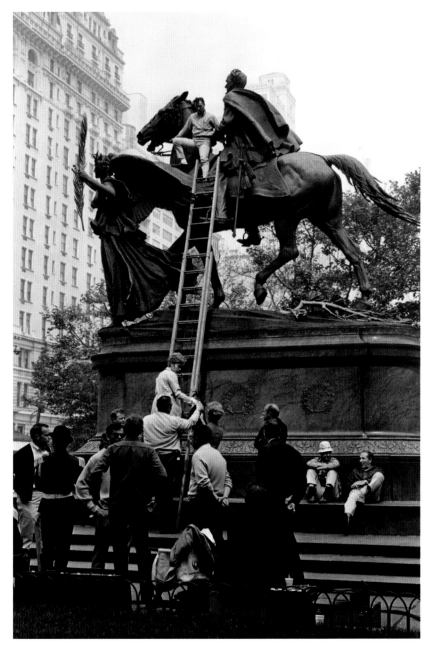

OSCAR LINDQUIST: The odds against us are at least a hundred to one. CHARITY HOPE Valentine: Those are the best odds I ever had.

Bob Fosse's film version of *Sweet Charity* was a love letter to New York City. In the span of one number, "I'm a Brass Band," we are whisked to Times Square, Yankee Stadium, Lincoln Center, the Brooklyn Bridge, Wall Street, and—of course—the Plaza. Here Shirley MacLaine gamely scales General Sherman.

Jack Lemmon Plaza-Style

Eight-time Oscar winner Jack Lemmon starred in more than sixty films, including *Some Like It Hot, The Apartment, Mister Roberts, The Odd Couple,* and *The Great Race.* Although he was born in Boston, attended Harvard, and lived most of his adult life in Los Angeles, Lemmon seemed somehow perfectly at home in New York City—perhaps because of his indelible turn as the impeccable Felix Unger in *The Odd Couple.* New York—and the Plaza—formed the backdrop for a few other Lemmon vehicles and milestone moments as well.

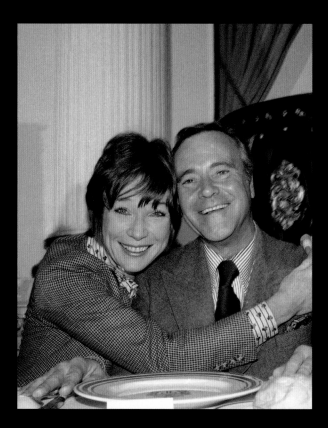

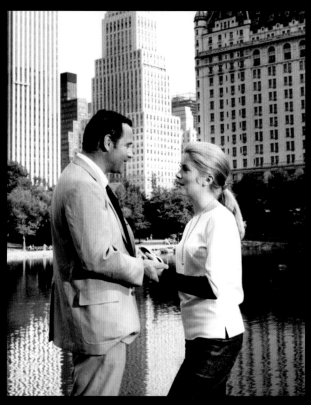

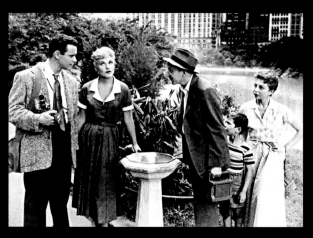

ABOVE LEFT: Jack Lemmon enjoys his fiftieth birthday party at the Plaza along with his costar from *The Apartment* and *Irma La Douce,* Shirley MacLaine. The year is 1975.

ABOVE RIGHT: The Plaza hovers behind Jack Lemmon and Catherine Deneuve as they stroll through Central Park in the 1969 film *The April Fools.*

LEFT: Inspired by the scenery, Lemmon falls for Judy Holliday in his first major screen role, the 1954 "rom-com," *It Should Happen to You.*

SUNDAY IN NEW YORK

Directed by Peter Tewksbury
Screenplay by Norman Krasna
Released in 1963

Fresh off of a breakup, 22-year-old Eileen considers herself "the only twenty-two-year-old virgin left in the world." While visiting her brother Adam in New York, she is determined to have some fun. Then her erstwhile fiancé shows up and things get complicated.

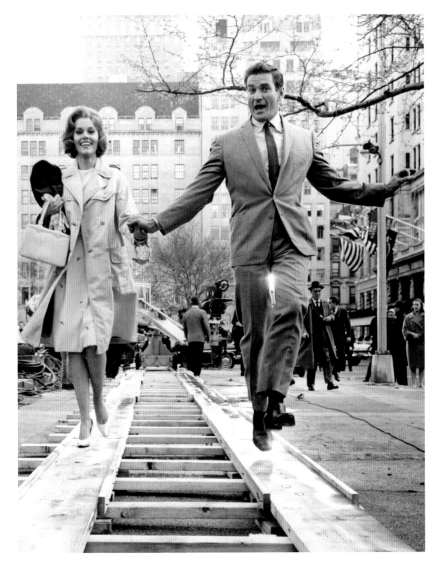

Jane Fonda and Rod Taylor spend a *Sunday in New York,* walking along the rails of a "tracking shot" in front of the Plaza. They are filming the 1963 movie version of the Broadway play (in which she played opposite her *Barefoot in the Park* costar Robert Redford) that showed Hollywood that Fonda could be an expert light-romantic comedienne.

ADAM TYLER: What is it that you'd like to know?

EILEEN TYLER: Are you ready?

ADAM TYLER: Shoot.

EILEEN TYLER: Is a girl that's been going around with a fellow for a reasonable length of time supposed to go to the bed with him or not?

ADAM TYLER: What kind of question is that to ask?

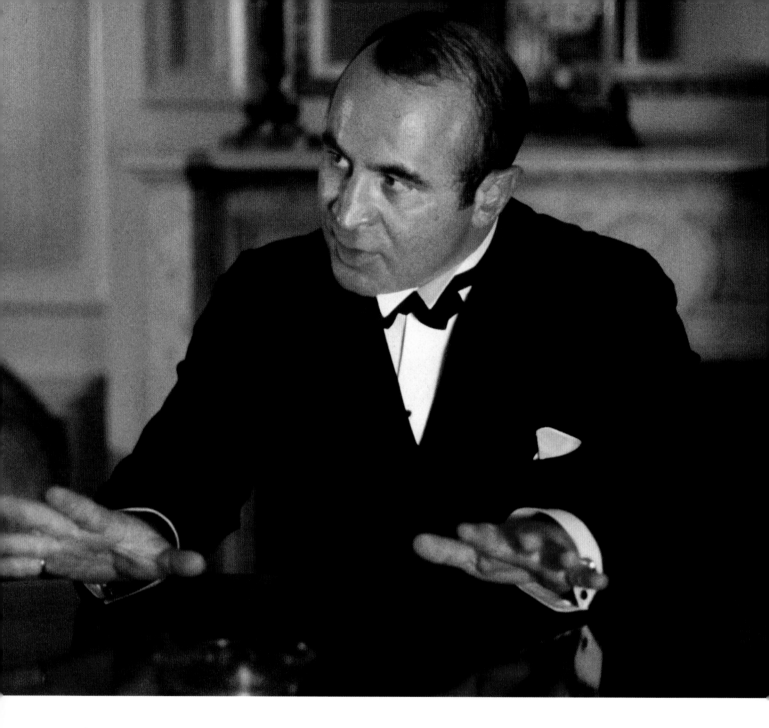

THE COTTON CLUB

Directed by Francis Ford Coppola
Screenplay by William Kennedy and Francis Ford Coppola
Released in 1984

This jazz-packed and star-studded film explores the lives and fortunes of the
people who ran, performed at, and attended Harlem's most illustrious nightclub.

LEFT: The brilliant Bob Hoskins makes his American film debut as ruthless gangster and Cotton Club owner Owney Madden.

BELOW: Richard Gere and Diane Lane in a scene from the opulently designed period piece, which was extensively rewritten during filming (at least twelve major rewrites of the screenplay were done in one five-week period). The delays in shooting ballooned the film's budget from 25 to 58 million, resulted in numerous lawsuits, and set off a downward spiral for Orion Pictures.

VERA: If he came in here right now, he'd kill us both.
DIXIE: Forget about him.
VERA: Who?

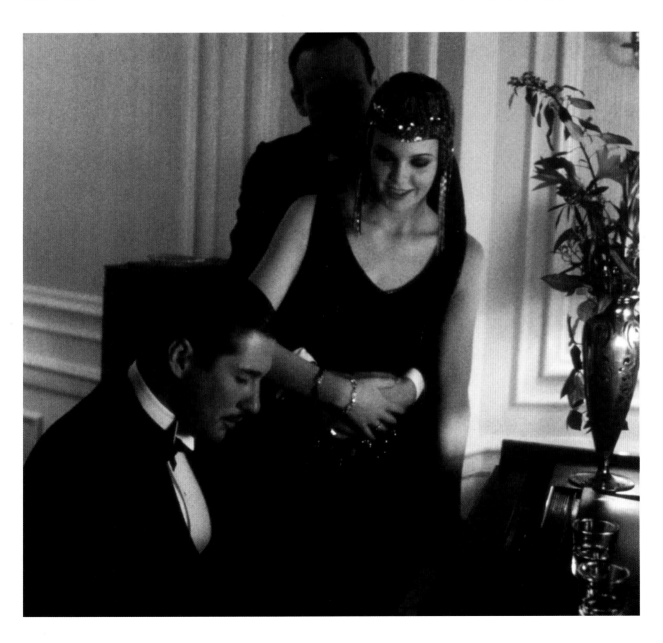

BREWSTER'S MILLIONS

Directed by Walter Hill
Screenplay by Herschel Weingrod and Timothy Harris
Released in 1985

A minor-league baseball player has to spend $30 million dollars in 30 days if he wants to inherit $300 million—but there's a catch. He's not allowed to tell anyone about the arrangement. Turns out, it's harder than it seems to blow a tall stack of cash.

Lonette McKee, John Candy, Richard Pryor, and David Wohl in the overnight-success "one-percent" fable *Brewster's Millions*. The 1902 novel clearly has something filmmakers are drawn to: it has been adapted for the screen ten times.

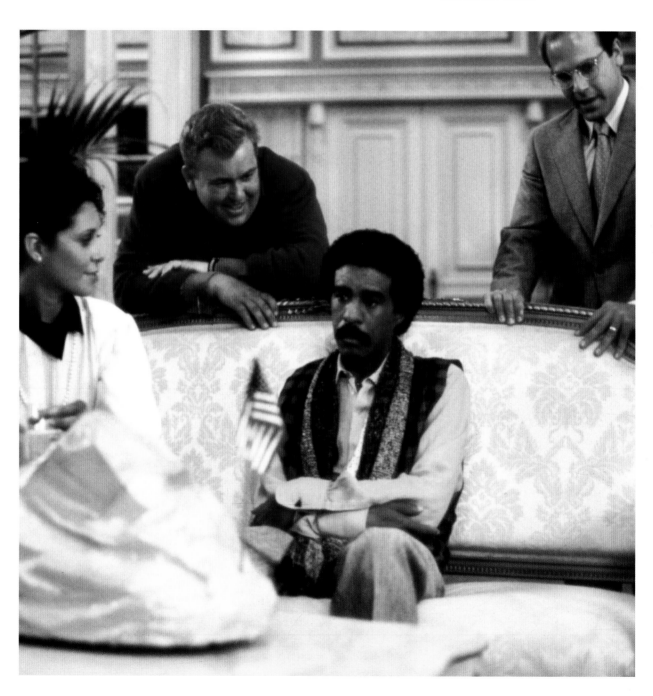

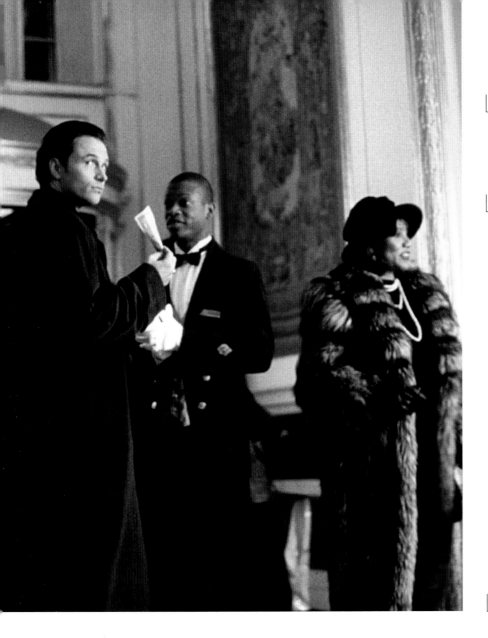

THE ASSOCIATE

Directed by Donald Petrie
Screenplay by Jean-Claude Carrière, Réne Gainville, and Nick Thiel
Released in 1996

In this Wall Street comedy, Laurel Ayres works hard at an investment firm only to watch her white male superiors snatch all the glory. What can she do but start her own firm? Things get tricky when she invents a male "partner" to lend her new venture some legitimacy.

ABOVE: Tim Daly and Laurence Gilliard, Jr., in a cut scene from *The Associate*, the first of two Whoopi Goldberg vehicles to shoot at the Plaza. (See page 45 for a glimpse of the other one.) And yes, there is a Donald Trump cameo in this film.

LOAN OFFICER: Do you have any assets?

LAUREL AYRES: Well, yeah. I have drive and courage and ambition. And if you'll look at the prospectus, you'll notice that I have a very, very sound business mind, too.

LOAN Officer: I was thinking more like stocks, bonds, property…

LAUREL AYRES: Ah. Now we're starting to sound a little like a "men's bank," aren't we?

LIFE OR SOMETHING LIKE IT

Directed by Stephen Herek
Screenplay by John Scott Shepherd and Dana Stevens
Released in 2002

A reporter interviews a supposedly psychic homeless man who tells her that her life is meaningless and she has only a few days to live. She decides to take charge of her destiny and make the most of what she's been given.

CAL: Is this you breaking up with me? Well, will you think about it for a minute?

LANIE: A minute just seems like a really long time to waste.

Lanie Kerrigan (Angelina Jolie) is skeptical when told by a "street prophet" (Tony Shalhoub) of her wasted life and impending demise. After all, her career is going great and she's staying at the Plaza. What could possibly go wrong?

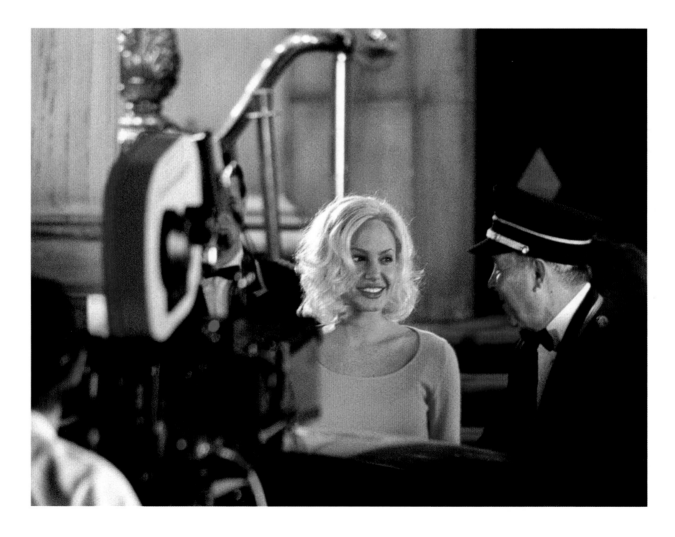

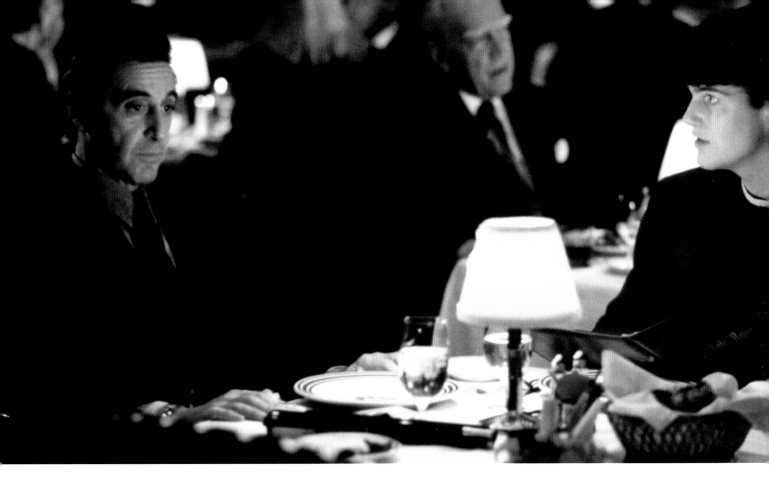

SCENT OF A WOMAN

Directed by Martin Brest
Screenplay by Bo Goldman
Released in 1992

A boarding school student trying to make some money for a plane ticket home agrees to take care of a blind, irascible retired army colonel over Thanksgiving weekend. When the older man whisks his "babysitter" off to New York for the weekend, they both get more than they bargained for.

Upon arrival in New York, Chaz (Chris O'Donnell) and Frank (Al Pacino) begin working their way down Frank's bucket list, which includes dinner at the Plaza's Oak Room. Chaz is shocked to see that the Oak Room Burger is a whopping $24. It won't be his final surprise.

FRANK: You don't wanna die.

CHARLIE: Neither do you.

FRANK: Give me one good reason not to.

CHARLIE: I'll give you two. You can dance the tango and drive a Ferrari better than anyone I've ever seen.

FRANK: You never seen anyone do either.

SEX AND THE CITY 2

Directed by Michael Patrick King
Screenplay by Michael Patrick King
Released in 2010

In their second film adventure, the four friends from the wildly popular TV series take a break from their Big Apple problems and fly off to exotic Abu Dhabi, where Samantha's ex is filming a movie.

SAMANTHA JONES: I'm having a hot flash.

CARRIE BRADSHAW: You're fine.

SAMANTHA JONES: Seriously. They're starting.

CARRIE BRADSHAW: You're on a camel in the middle of the Arabian desert. If you're not having a hot flash, you're dead.

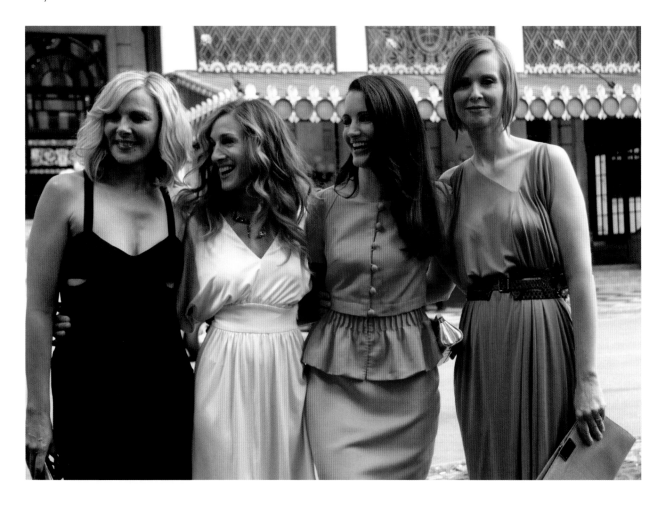

BELOW: Friends to the end Samantha Jones, Carrie Bradshaw, Charlotte York Goldenblatt, and Miranda Hobbes (Kim Cattrall, Sarah Jessica Parker, Kristin Davis and Cynthia Nixon), follow up a shopping spree at Bergdorf Goodman with a visit to the Plaza.

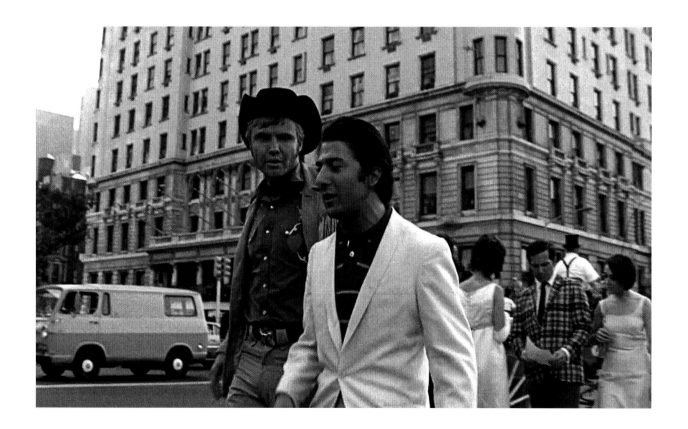

MIDNIGHT COWBOY

Directed by John Schlesinger
Screenplay by Waldo Salt
Released in 1969

A naïve Texas hayseed makes his way from Texas to New York City to be a big-time "hustler" but quickly finds himself out-hustled. Then he befriends a sketchy character named Ratso Rizzo and the unlikely duo take care of each other in unexpected ways.

JOE BUCK: I'm brand, spankin' new in this here town and I was hopin' to get a look at the Statue of Liberty.

CASS: It's up in Central Park taking a leak. If you hurry, you can catch the supper show.

ABOVE: Jon Voight and Dustin Hoffman hit the streets of New York City, looking for the perfect angle to turn a quick (Joe) Buck.

BELOW: John Schlesinger and the crew filming on location in Grand Army Plaza.

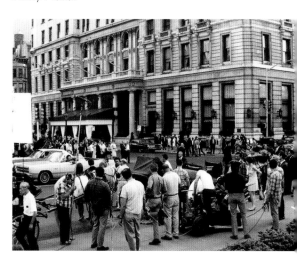

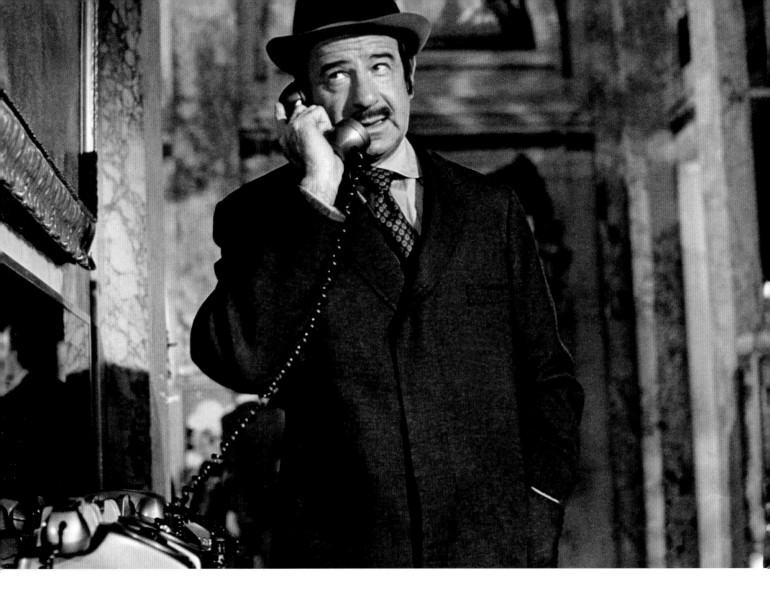

PLAZA SUITE

Directed by Arthur Hiller
Screenplay by Neil Simon
Released in 1971

Three separate stories unfold in Suite 719 of the Plaza Hotel. In the first, a suburban couple takes stock of their marriage on their twentieth wedding anniversary; in the second, a womanizing Hollywood producer with a few hours to kill rekindles an old flame; and in the third, a reluctant bride hides out in a locked bathroom as the guests gather for the ceremony.

ABOVE: The eternally dyspeptic Walter Matthau checks into Suite 719 at the Plaza three times, as three different characters. Playwright Neil Simon, who also wrote the screenplay, later confessed that he didn't care for Matthau's portrayal of the first two characters in the movie, and much preferred the more varied performance of George C. Scott in the Broadway production.

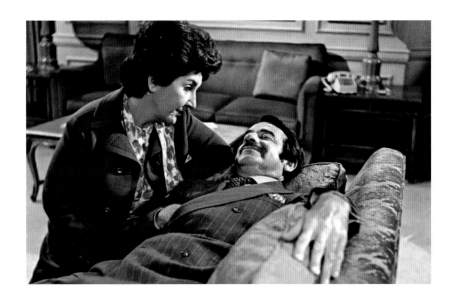

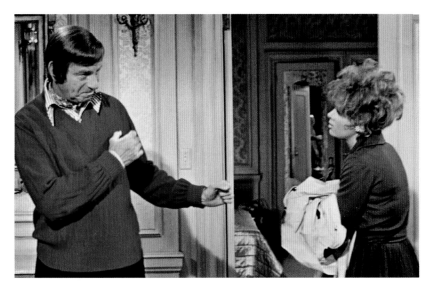

TOP, MIDDLE AND BOTTOM: When the movie version of *Plaza Suite* was announced in 1969, Paramount Pictures issued a press release saying that the film would star George C. Scott and Maureen Stapleton, recreating their Broadway roles, in "Visitor from Mamaroneck"; Peter Sellers and Barbra Streisand in "Visitor from Hollywood"; and Walter Matthau and Lucille Ball in "Visitor from Forest Hills." In the end, only Stapleton and Matthau wound up in the final film. Matthau did triple duty, while another Barbara (Harris) and Lee Grant played the other women.

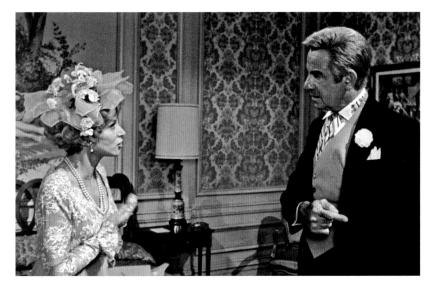

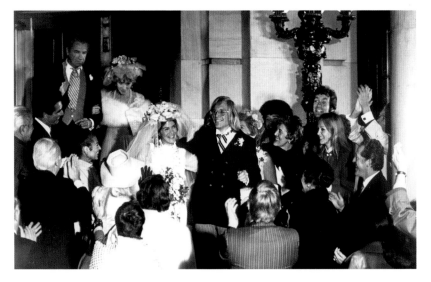

LEFT: The farcical wedding nightmare finally concluded, Walter Matthau and Lee Grant exit the Plaza with their newlywed daughter and her husband (Jenny Sullivan and Thomas Carey).

BELOW: Matthau as a Hollywood producer on the make, trying every play in the book to bed one of the quirkiest actresses of the 1960s, Barbara Harris. Thanks to her training at Chicago's Second City, Harris possessed that magical ability to make every line of dialogue seem completely improvised.

NORMA HUBLEY: Roy, just talk nicely and she'll come out.
ROY HUBLEY: We've had nice talking, now we're gonna have door breaking.

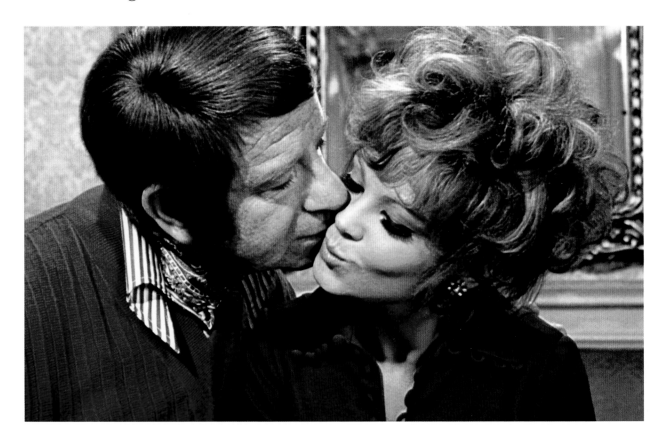

RIGHT: Maureen Stapleton (fresh off an Oscar nomination for her role as a desperate wife in *Airport*) and Walter Matthau kick off the three-part film as the long-married "Visitors from Mamaroneck."

BELOW: Barbara Harris strolls through the lobby of the actual Plaza, in a movie that includes more footage shot at the hotel than any other.

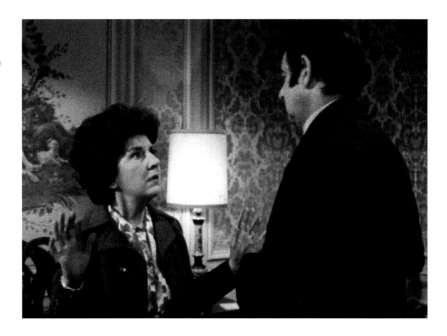

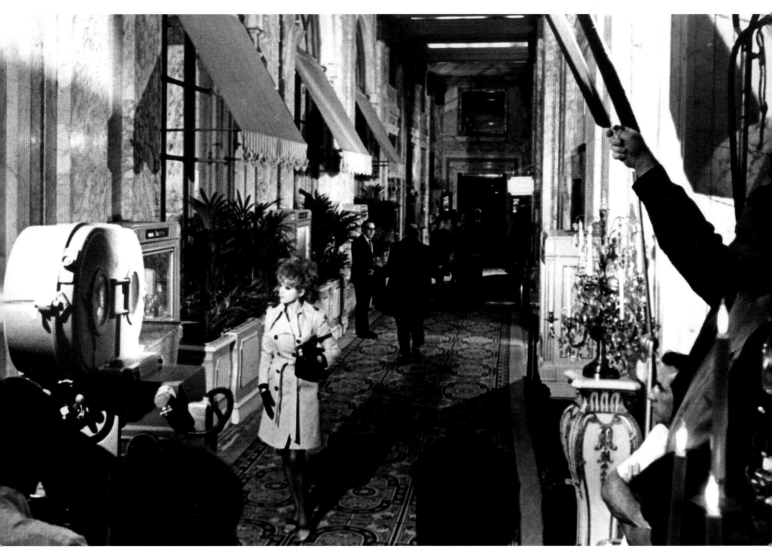

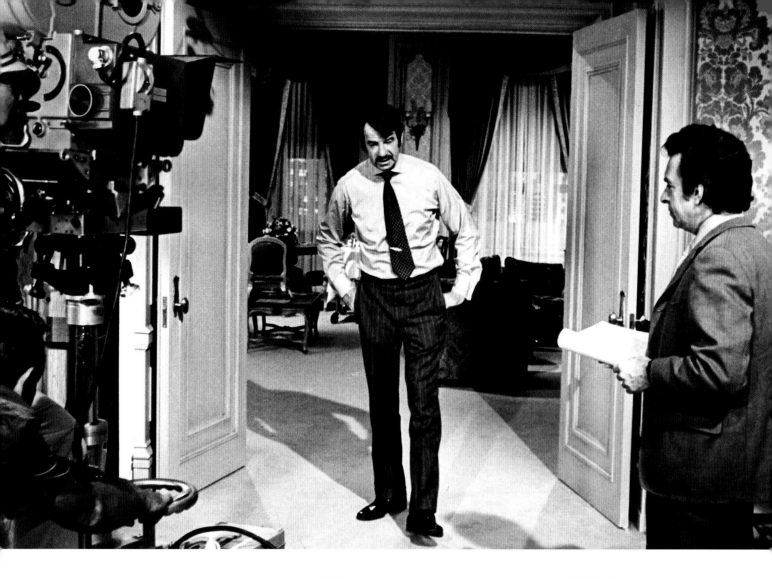

ABOVE: Walter Matthau and director Arthur Hiller (hot off the smash success 1970 tearjerker *Love Story*) on a Paramount sound stage substitute for the Plaza.

RIGHT: Matthau as the oily Jesse Kiplinger and actor Jordan Charney as Kiplinger's toady assistant, filming outside the Plaza.

ABOVE: Lee Grant (who starred in the play's national tour) finally got to commit all three *Plaza Suite* roles to film when she played opposite Jerry Orbach in a 1982 HBO version of the play.

RIGHT: In December 1987, Carol Burnett played all three Plaza women opposite Dabney Coleman, Hal Holbrook, and Richard Crenna, respectively. (Hey, why should Walter Matthau have all the fun?) The broadcast of this ABC-TV version of *Plaza Suite* was interrupted by a special report about the Reagan and Gorbachev INF Treaty summit. The action was preempted in the middle of Act 1, with Burnett married to Holbrook; skipped the Dabney Coleman segment entirely; and picked up the action again with Burnett now married to Crenna. The viewing audience was...confused.

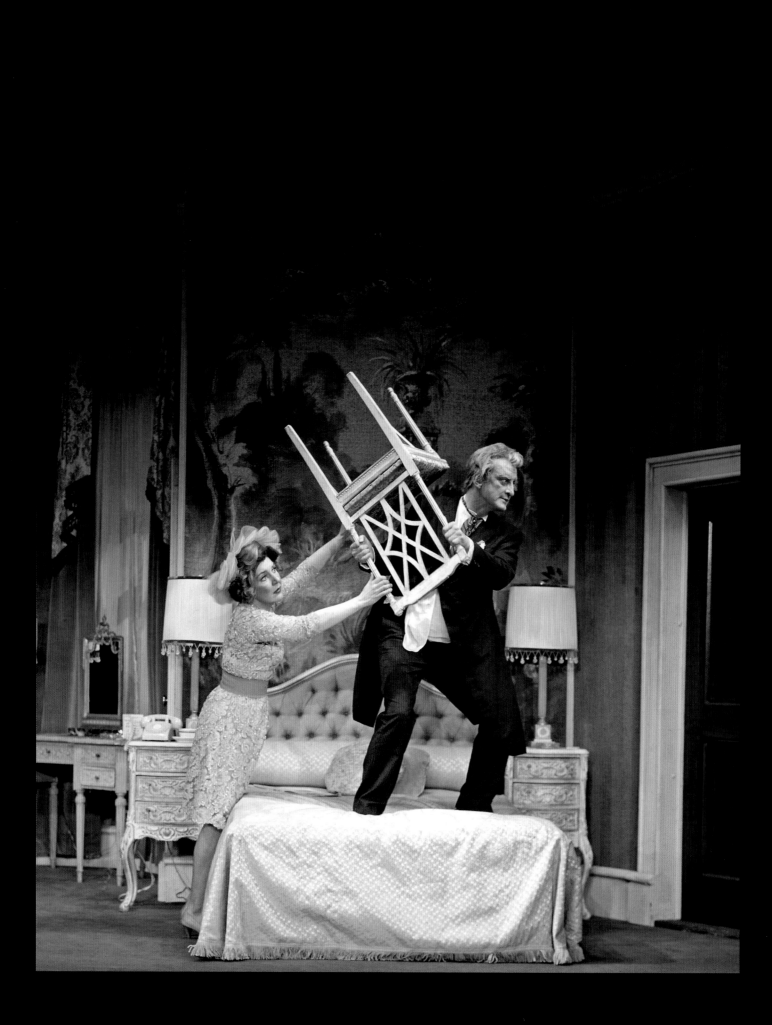

THE PLAZA

on Stage

When Neil Simon was asked why he chose the Plaza as the site of his by turns touching and slapstick theatrical anthology, *Plaza Suite*, he replied that it simply never occurred to him to place it anywhere else. It was up to his set designer, Oliver Smith, to try to summon up that Plaza magic on stage—and he must have done a pretty good job of it: The show ran for more than a thousand performances, has been revived on stage and adapted for the screen numerous times, and has become a staple of regional theaters everywhere. (OK, maybe Simon's genius has more to do with the play's longevity than the glories of the Plaza…but let's face it: The name is gold.)

Though there aren't as many plays as films set at the Plaza, the hotel itself has been home to some rather un-Plaza-like theatrical activity, in the form of Off Broadway shows and revues that took root in its more obscure basement spaces. Does it surprise you that a corner of the Great Lady was once transformed into a seedy Mexican supper club? Truth.

PLAZA SUITE

By Neil Simon
Directed by Mike Nichols
Opened in 1968

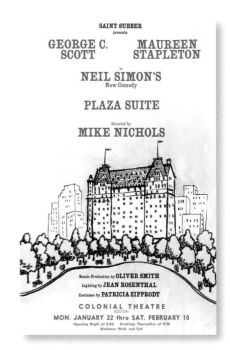

Like the film that was adapted from it, *Plaza Suite* comprises three one-acts, all of which take place in the same suite at the Plaza: "A Visitor from Mamaroneck," "A Visitor from Hollywood," and "A Visitor from Forest Hills."

When Plaza Suite went into rehearsal it consisted of four acts, but the evening was running long so it was cut down to three. Never one to waste a good story, playwright Neil Simon ultimately expanded the deleted story and turned it into the 1970 film *The Out-of-Towners*.

BELOW: The most synthetically coiffured couple of 1968, Maureen Stapleton and George C. Scott, in the second act of Plaza Suite.

PREVIOUS PAGE: George C. Scott goes ballistic in the final act and the action dissolves into out-and-out slapstick farce.

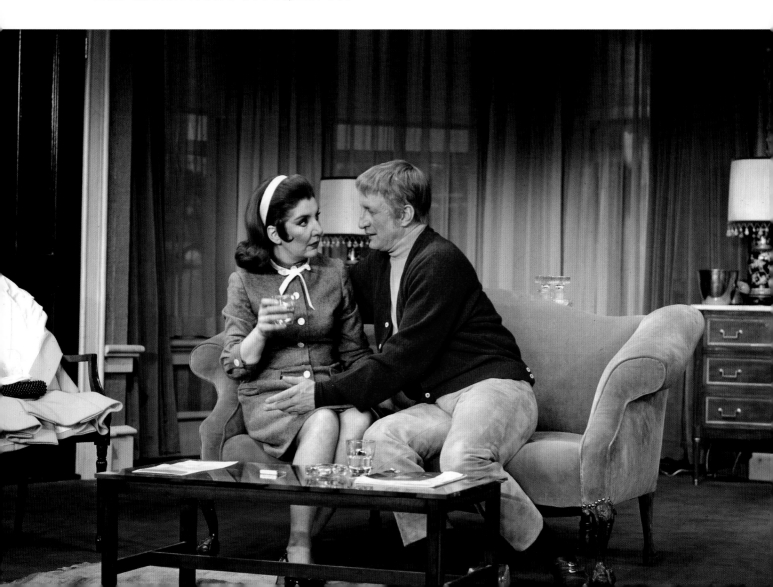

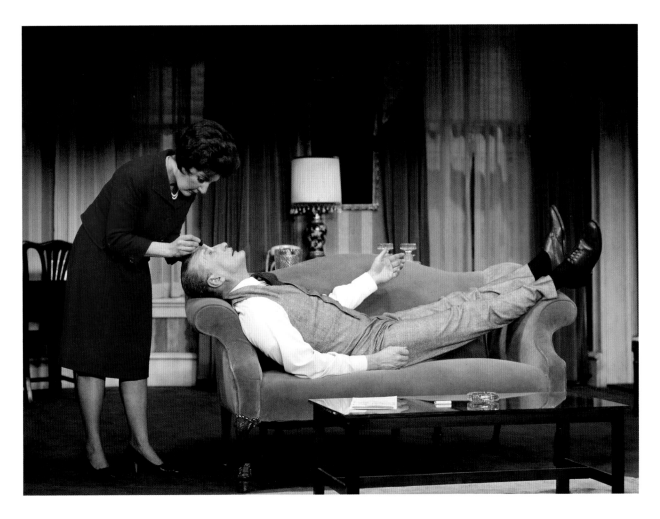

SAM: You forgot my pajamas?

KAREN: I didn't forget them, I just didn't bring them.

SAM: Why not?

KAREN: Because this is Suite 719 at the Plaza and I just didn't think you'd want your pajamas tonight!

ABOVE: The longtime marriage of Stapleton and Scott hits the rocks in the bittersweet first act of *Plaza Suite*.

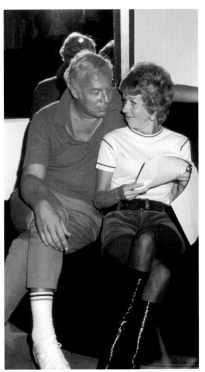

LEFT: George Kennedy and Carol Burnett hold a press conference for their 1971 production of *Plaza Suite* at the Huntington Hartford Theater in Los Angeles.

JULIUS MONK

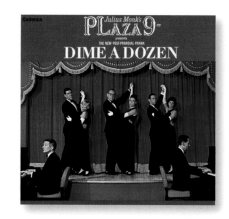

In 1962, in a basement room that had been a restaurant called the Rendez-Vous, a little theater/cabaret was created called PLaza 9. (Note the capital *P* and *L*, a nod to the phone exchange of that area of Manhattan.) Its purpose was to showcase the unique talents of one Julius Monk. Monk performed numerous original satiric revues there, including one in which four Harvard professors sang:

Don't do the beguine
Take the mescaline
And the visions you'll have
Are sure to be obscene…

Monk's PLaza 9 revues included *Dime a Dozen* (1962), *Baker's Dozen* (1964), and *Bits & Pieces XIV* (1964), and featured several unknowns who would go on to fame, including Ken Berry and Ruth Buzzi. His last show, *Four in Hand*, closed in June of 1968.

Ceil Cabot (known for dozens of guest shots on 1960s and '70s sitcoms), Susan Browning (best known for singing "Barcelona" in Stephen Sondheim's *Company*), and Mary Louise Wilson (much later a Tony winner for *Grey Gardens*) in *Dime a Dozen*.

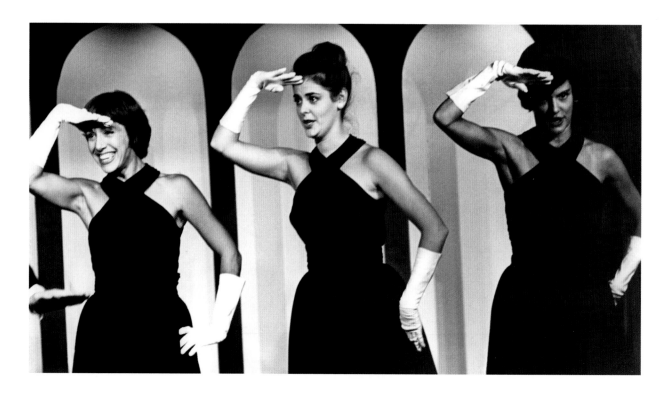

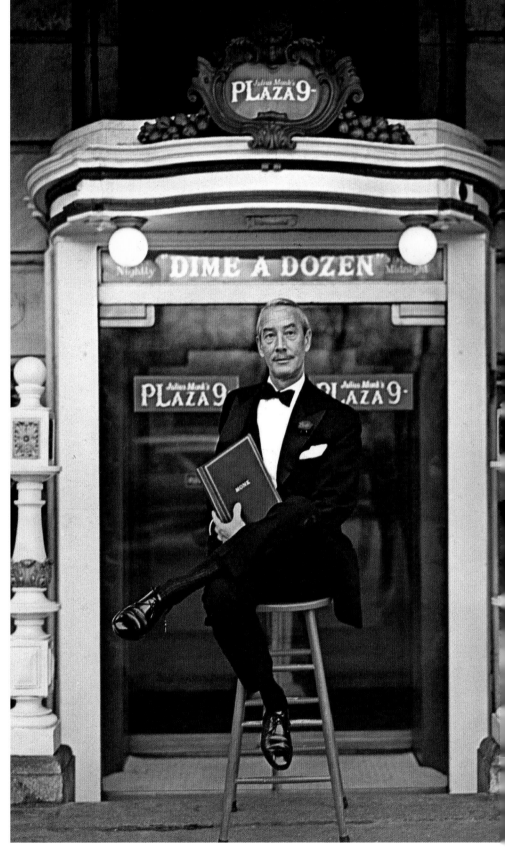

Elegant yet deeply complicated, Julius Monk sits on a stool (standard equipment for cabaret) in front of his theatre. His revues in the 1950s and '60s helped launch the careers of Tammy Grimes, Estelle Parsons, Alice Ghostley, Jane Connell, Jonathan Winters, Linda Lavin, Madeline Kahn, Charles Kimbrough, Nancy Dussault, and Lily Tomlin.

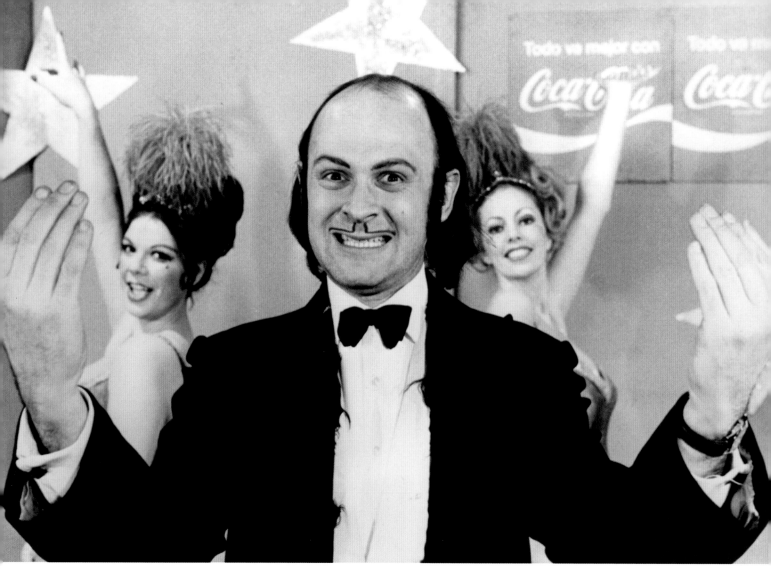

EL GRANDE DE COCA COLA

By Diz White, Ron House, John Neville Andrews, Alan Shearman,
 and Sally Willis
Musical arrangements by John Neville Andrews and Alan Shearman
Opened in 1973

A cult sensation from the moment it opened, the Mexican cabaret-parody *El Grande de Coca Cola* takes place in a terrible part of Trujillo, in a seedy nightclub. Senor Don Pepe Hernandez determines to bring "international cabaret" to the club and eventually succeeds—at which point the hilarious cabaret-within-the-cabaret unfolds.

ABOVE: Sally Willis, Ron House, and Diz White as Don Pepe Hernandez and his daughters, the cheesy entertainment at the diviest dive in Trujillo. Believe it or not, the odd but irresistible little musical won the blessing of the Coca-Cola Company.

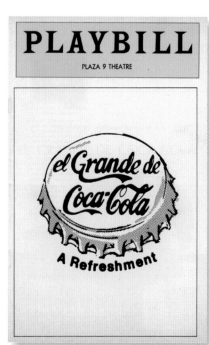

DAMES AT SEA

Book and lyrics by George Haimsohn and Robin Miller
Music by Jim Wise
Directed by Robert Dahdah
Opened in 1966

This tap-happy little show—part parody, part loving tribute—celebrates the golden age of movie musicals by assembling an array of beloved backstage character types who must find a theater and put on a show. The temperamental diva star, the wisecracking chorus girl, the naïve young talent, and the songwriting sailor join forces, and a few of them join hearts in the process. Will the curtain go up? What do you think?

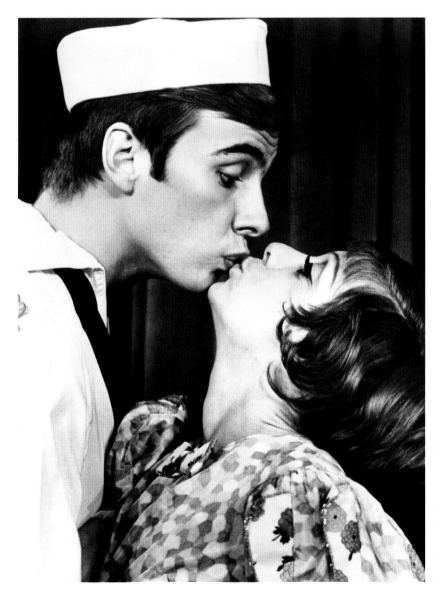

RUBY: You know, Uncle Gus just loved to watch me dance. "Ruby," he'd say, "your feet sing. Those tapping toes of yours are going to take you a long way!"

DICK: And so they have. You're on Broadway!

RUBY: Gosh! So I am!

Kurt Peterson (soon to be featured in Stephen Sondheim's classic musical *Follies* on Broadway) and Leland Palmer (of Bob Fosse's brilliant movie *All That Jazz*), star as Dick and Ruby in another backstage musical, *Dames at Sea*, a revival of which opened at the PLaza 9 Music Hall in September of 1970.

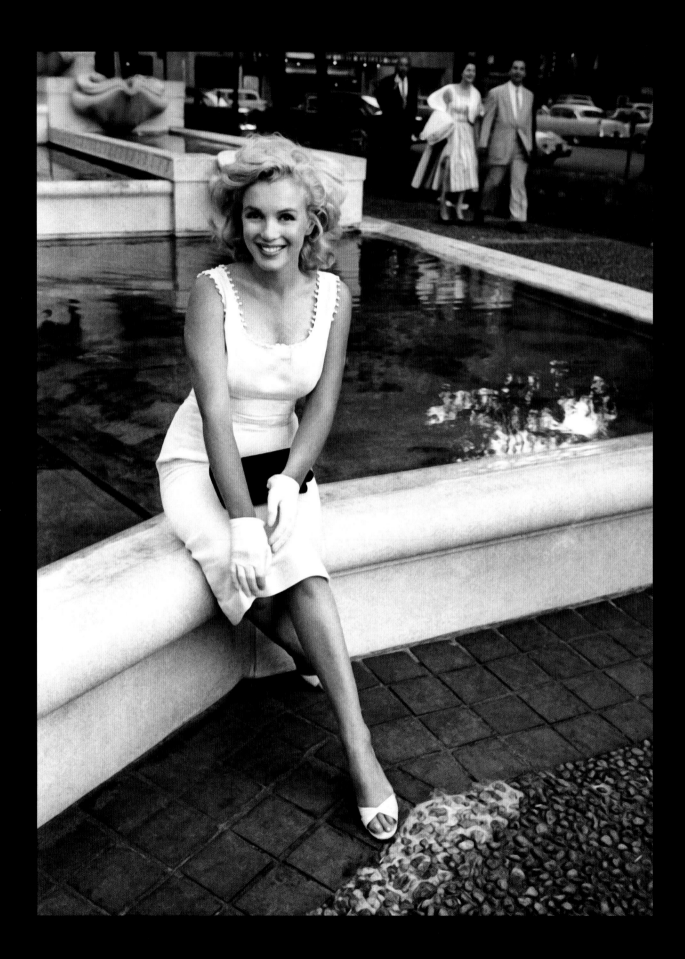

Paparazzi, Press, Parties & Premieres

The Plaza has been the backdrop for numerous photo ops of all kinds—from celebrity-packed press events to swanky A-list premieres and parties. And why not? The soft light reflecting off of its Italian mosaic-tiled foyers and gold-and-crystal chandeliers would make anybody look like a million dollars.

Elizabeth Taylor and Richard Burton, Bridget Bardot, Marilyn Monroe, The Beatles…it would be easier to list the top-drawer stars who *haven't* cavorted there over the years. And the constant presence of photographers has become our own good fortune. We had quite a hard time choosing from among the many shots in the archives—but we especially love the ones that show unlikely alliances and friendships. And, lest you think it was all glitz, the Plaza has hosted many international political gatherings as well, including the 1985 Plaza Accord, during which international finance ministers met to discuss the world's economic future.

Anyone who is anyone in New York society has passed through the portals of the Plaza's Grand Ballroom. That's where Truman Capote held his ultra-exclusive Black and White Ball. And, let's just say that a few pounds of rice have been swept up from those mosaic tiles over the years. Are you getting the picture? If it didn't happen at the Plaza, it didn't happen.

PAPARAZZI

Celebrity photographers are a fixture at the Plaza, and the ones with patience and a high capacity for alcohol win the prize when an A-lister happens in after a night on the town. The Palm Court is a favorite spot for snapping society doyennes and superstars enjoying afternoon tea. One of my fondest memories is of enjoying a late-afternoon pot of Earl Grey and tray of tea sandwiches with Celeste Holm. Who do you suppose we spotted at an adjacent table, indulging in the same genteel tradition? Since you'll never guess, I'll tell you: the Queen of Soul herself, Aretha Franklin.

On the other end of the spectrum of gentility, some clandestine romances have been blown wide open by the Plaza paparazzi, so be warned: If you want to stay under the radar, best not to put the Plaza on your flight plan.

PREVIOUS PAGE: Marilyn Monroe sits by the Pulitzer Fountain in 1957.

BELOW: Harrison Ford and Carrie Fisher on the Fifth Avenue side of the Plaza in 1977, during a press junket for the original *Star Wars*.

OPPOSITE: From a cotton plantation in South Carolina to the Plaza: the fabulous entertainer Eartha Kitt, poses in typically regal fashion in a suite in 1992.

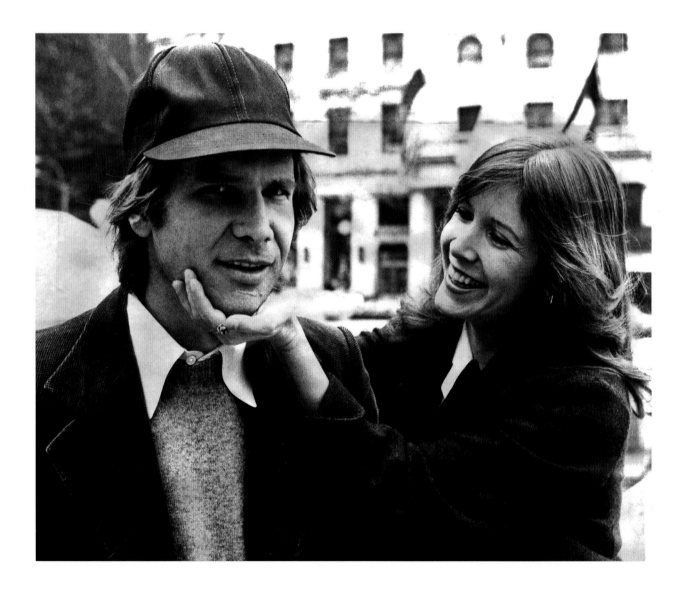

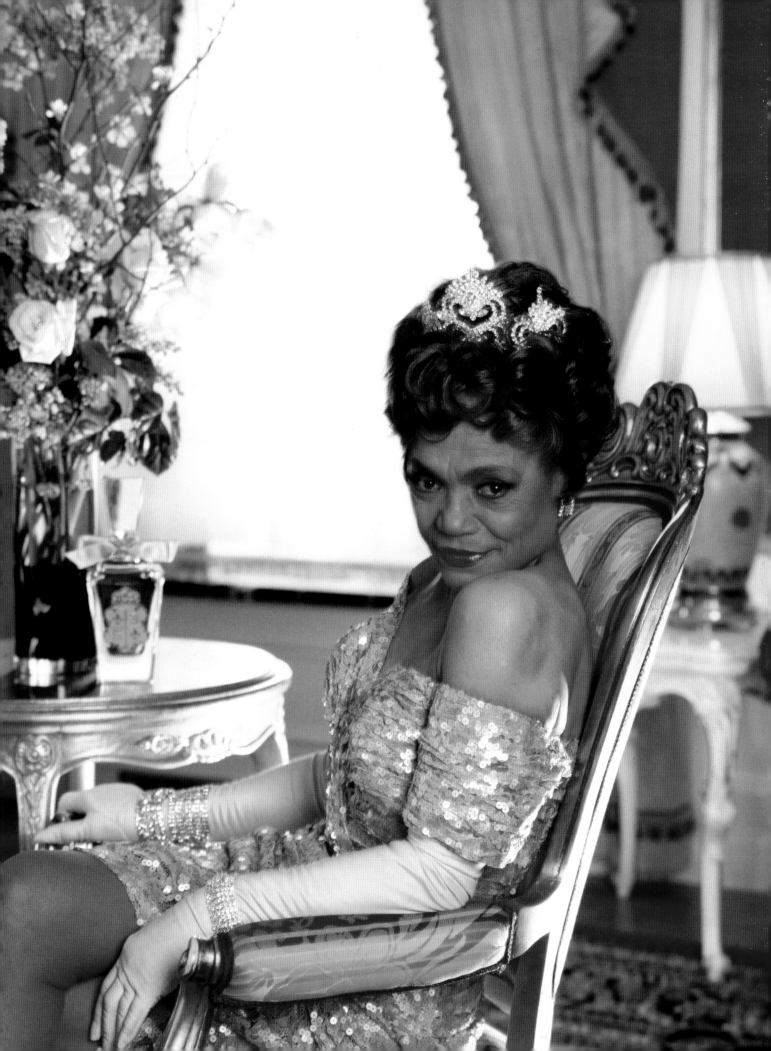

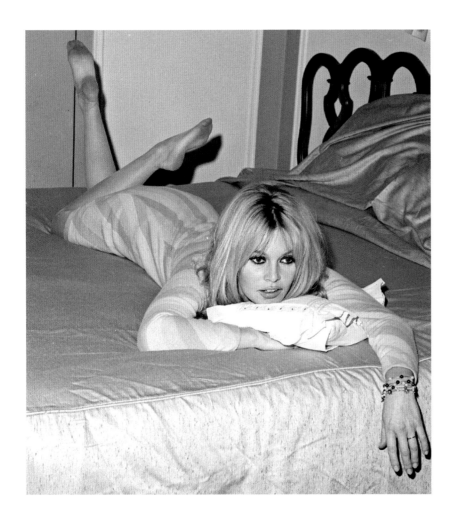

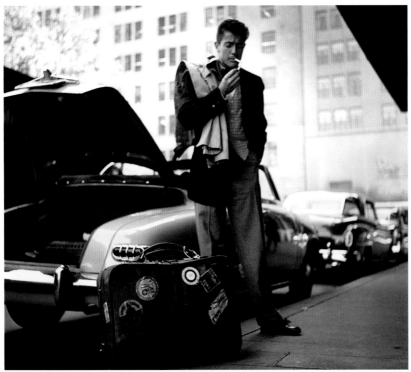

ABOVE: Exhausted by her punishing schedule, Brigitte Bardot takes to her bed during an interview at the Plaza in December of 1965. Shortly after this shot was taken, her doctor ordered dark glasses to protect her eyes, which tended to become irritated by the glare of all the flashbulbs.

LEFT: Farley Granger, the star of the Hitchcock favorites *Rope* and *Strangers on a Train*, checks into the Plaza in 1955.

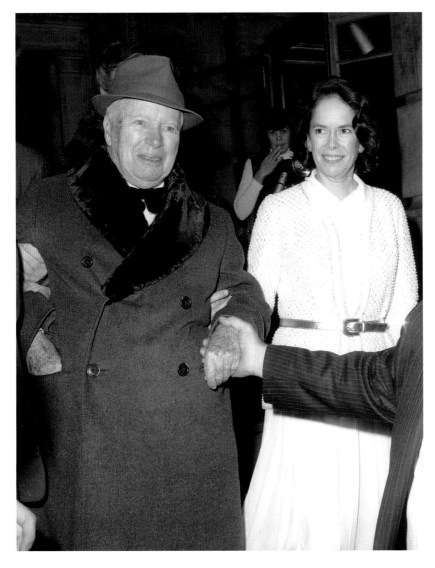

LEFT: In 1973, Charlie Chaplin and his wife Oona made the Plaza their first stop in the U.S. after twenty years in exile.

BOTTOM LEFT: Judy Garland and her third husband, Sid Luft, with Judy's ten-year-old daughter Liza Minnelli, in their suite at the Plaza in September of 1956. Judy had just made a triumphant return to live performing at the Palace Theatre, starting a smash four-month run.

BOTTOM RIGHT: Joan Crawford at the Plaza on May 21, 1970, while accepting the Marketing Woman of the Decade award for her work for the Pepsi-Cola Company.

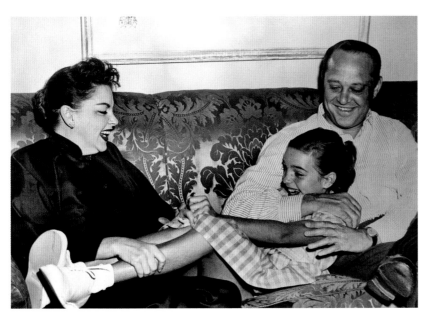

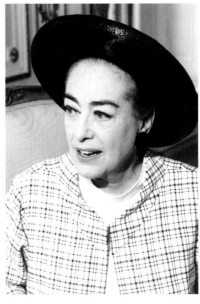

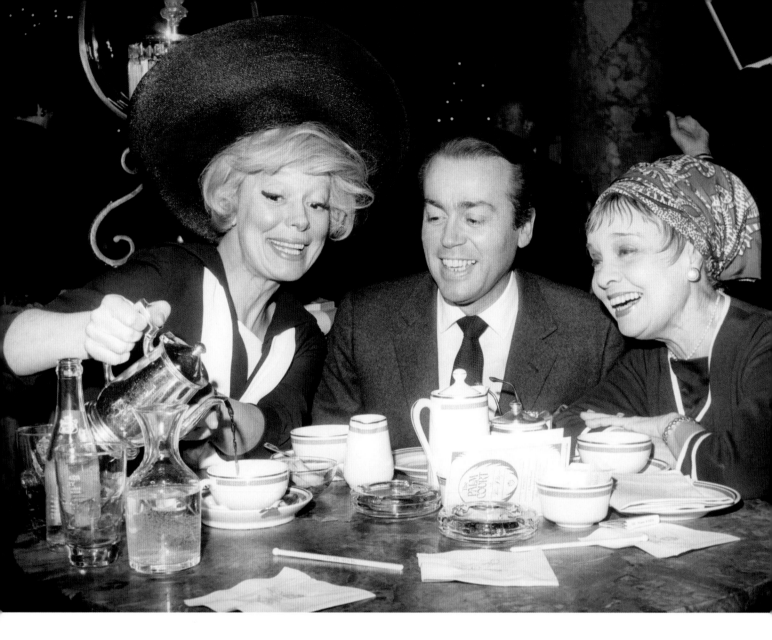

ABOVE: Carol Channing, playwright Jean-Pierre Gredy, and Anita Loos—the creator of Channing's starmaking role in *Gentlemen Prefer Blondes*—have a spot of tea at the Palm Court in 1964.

LEFT: Vanessa Williams, the newly crowned (and soon to be uncrowned) Miss America, strikes a pose at the Pulitzer Fountain in September of 1983.

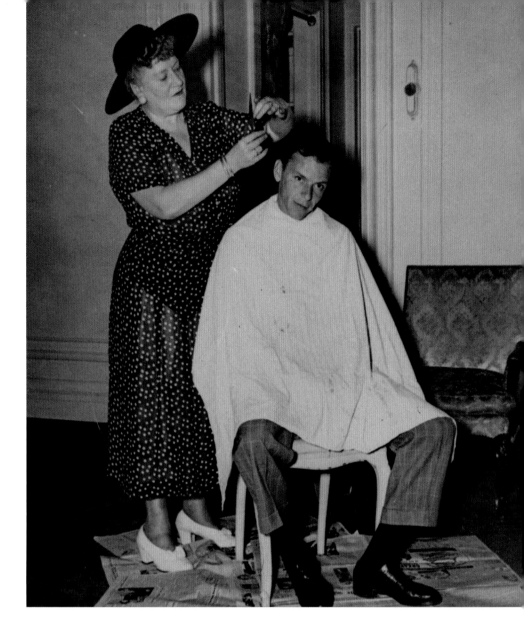

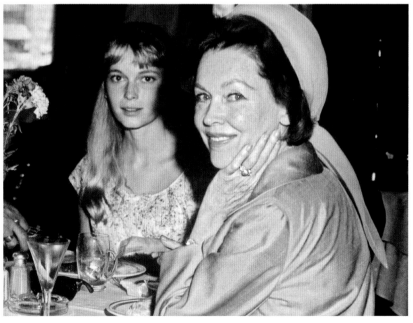

ABOVE: Frank Sinatra gets a haircut by his favorite stylist, Mrs. Frances Murphy, in his suite at the Plaza in June of 1949.

RIGHT: Mia Farrow and her mother, actress Maureen O'Sullivan, lunch at the Plaza in August of 1965. Farrow had just begun a romance with Frank Sinatra, whom she would marry the following year.

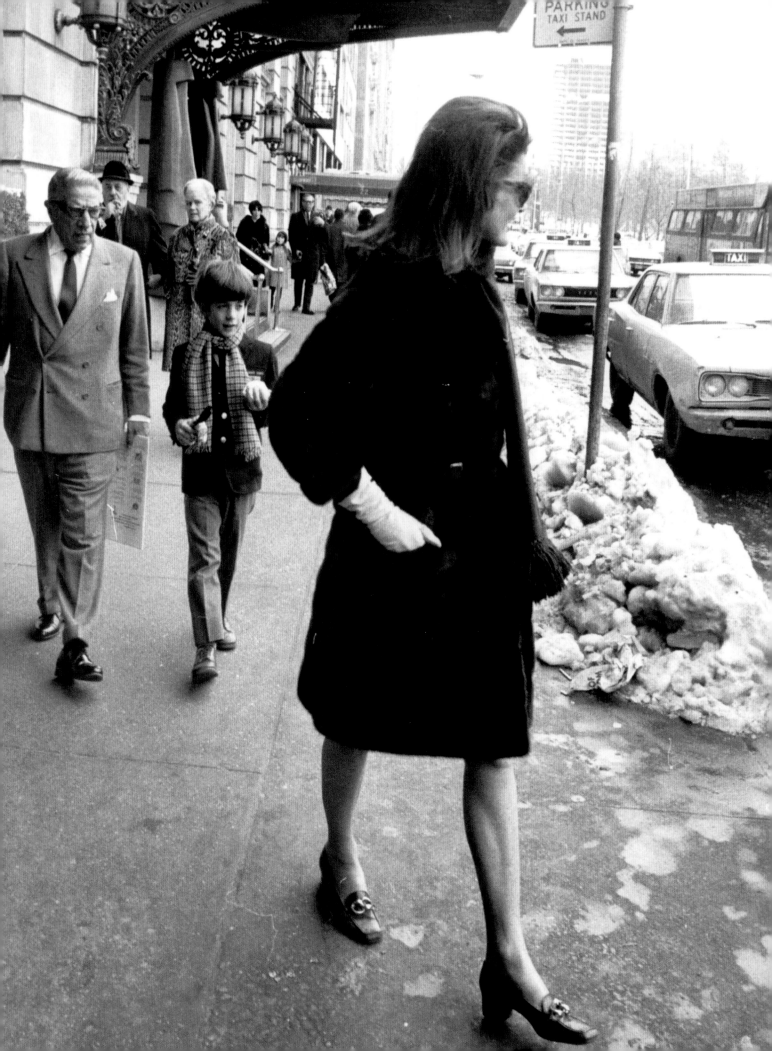

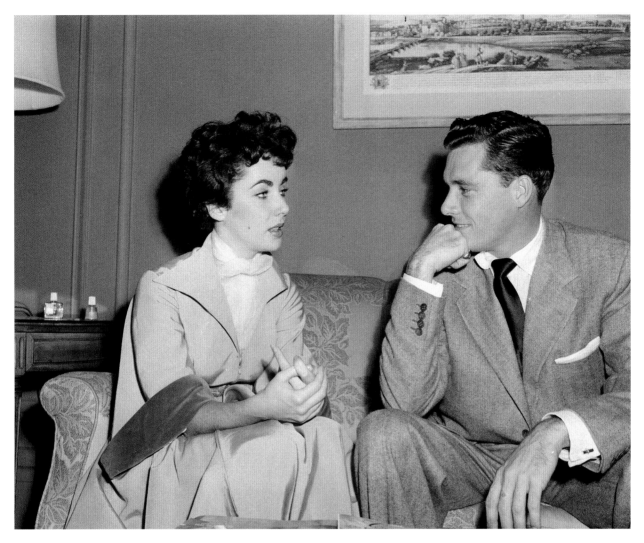

ABOVE: Elizabeth Taylor and soon-to-be ex-husband Conrad "Nicky" Hilton, Jr. talk in her suite, while meeting with reporters and lawyers to discuss their impending divorce, in October of 1951.

RIGHT: Richard Burton outside the Plaza in May of 1969.

LEFT: Aristotle Onassis; John Kennedy, Jr.; and his mother, Jacqueline Bouvier Kennedy Onassis, attempt to avoid the paparazzi outside the hotel in February of 1969.

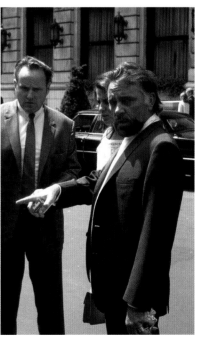

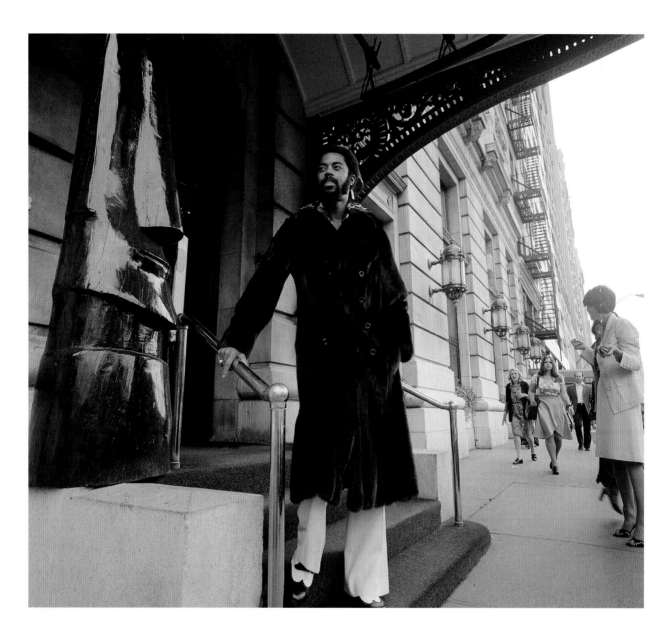

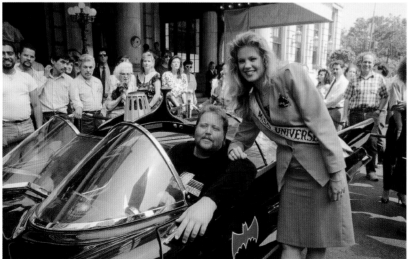

ABOVE: Basketball legend Walt Frazier models a black mink coat outside the hotel in September of 1974.

LEFT: Scott Chinery, owner of the Batmobile, sits in front of the Plaza in June of 1989, joined by Miss Universe, Angela Visser.

OPPOSITE: Accompanied by her stepdaughter, Kate Burton, Elizabeth Taylor parades her dog through the lobby in May of 1969.

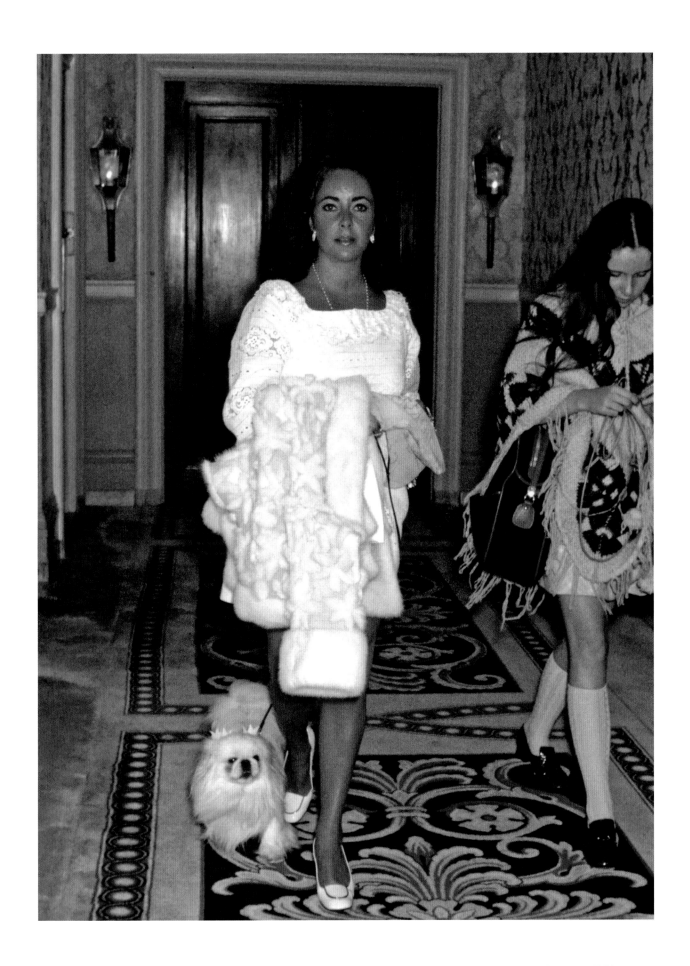

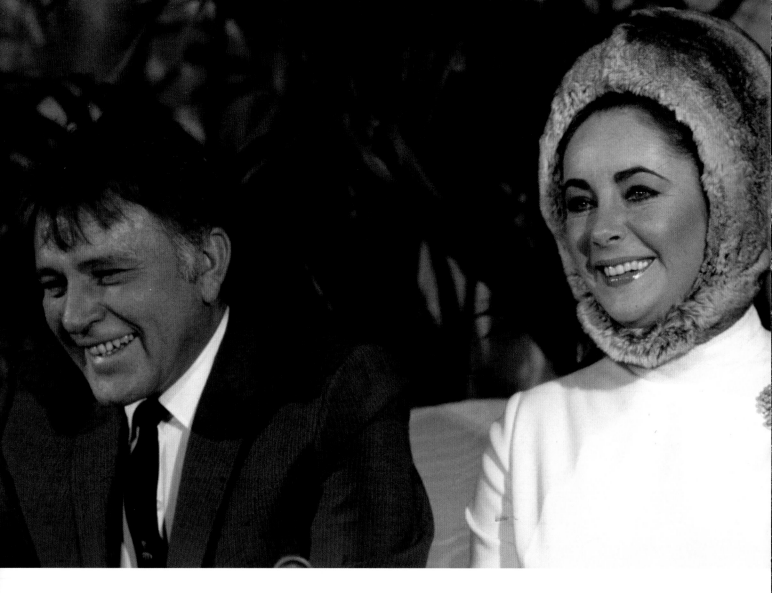

PRESS

"If you announce it at the Plaza, they will come." OK, that's not exactly how the saying goes, but it's certainly true. If you want to attract some press attention—for your product, service, or blessed event—make your announcement at the Plaza.

ABOVE: Richard Burton and Elizabeth Taylor hold a press conference to hype their 1967 film *Dr. Faustus.*

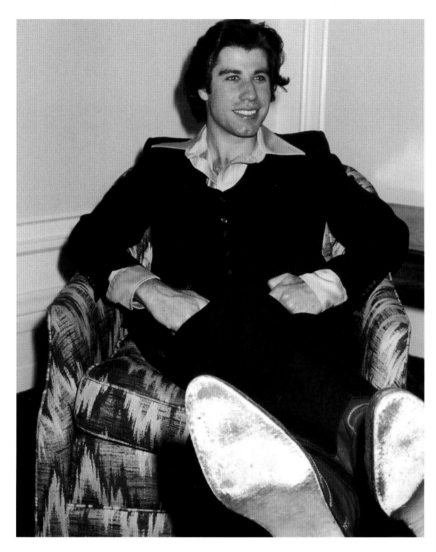

LEFT: John Travolta relaxes in his suite in December 1977, during a press junket for his starmaking role as Tony Manero in *Saturday Night Fever*.

BOTTOM LEFT: Woody Allen endures a press conference in September of 1992, the purpose of which was to respond to molestation charges made by longtime partner Mia Farrow.

BOTTOM RIGHT: Actress and singer Cher promotes her new perfume, "Uninhibited," in August of 1988.

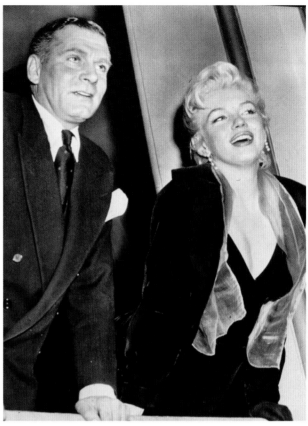

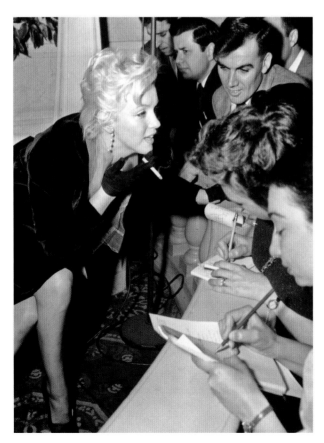

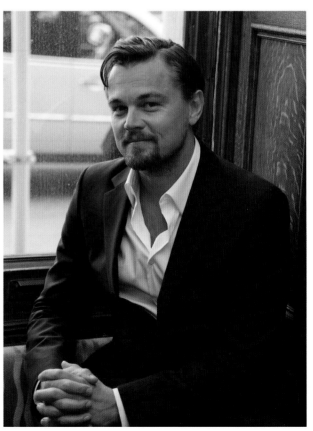

OPPOSITE TOP LEFT: Brigitte Bardot publicizes her new movie, *Viva Maria,* in December of 1965.

OPPOSITE TOP RIGHT: Laurence Olivier and Marilyn Monroe greet reporters during a press junket for their 1957 film *The Prince and the Showgirl.*

OPPOSITE BOTTOM LEFT: Marilyn Monroe bestows an interview on eager reporters in Febraury of 1956. She was quoted as whispering, "I'd like to continue my growth in every way possible."

OPPOSITE BOTTOM RIGHT: Leonardo DiCaprio speaks to the press about *The Great Gatsby* at the Oak Bar of the Plaza in April of 2013.

RIGHT: A journalist interviews Audrey Hepburn about her new film, *Breakfast at Tiffany's,* in October of 1961.

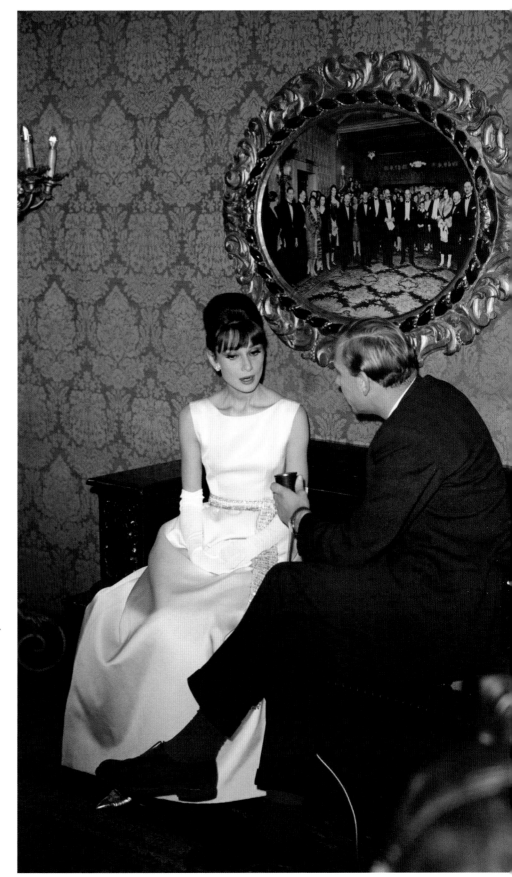

PARTIES

The Plaza never shines so brightly as when someone is throwing a lavish event in one of its grand spaces. Weddings, debutante balls, movie premieres—you name it. Anyone who has ever planned a once-in-a-lifetime occasion has contemplated (or at least dreamed about) holding it at the hotel. Here's a tip, though: If you are really serious about getting married at the Plaza, plan on a long engagement. Some of its most beautiful spaces are booked up years in advance.

BELOW: Chevy Chase leaves the *Saturday Night Live* Fortieth Anniversary Celebration after party on February 15, 2015.

OPPOSITE: Lena Horne transformed herself into another African queen—Cleopatra—for the eighth annual Fan Ball in November of 1957.

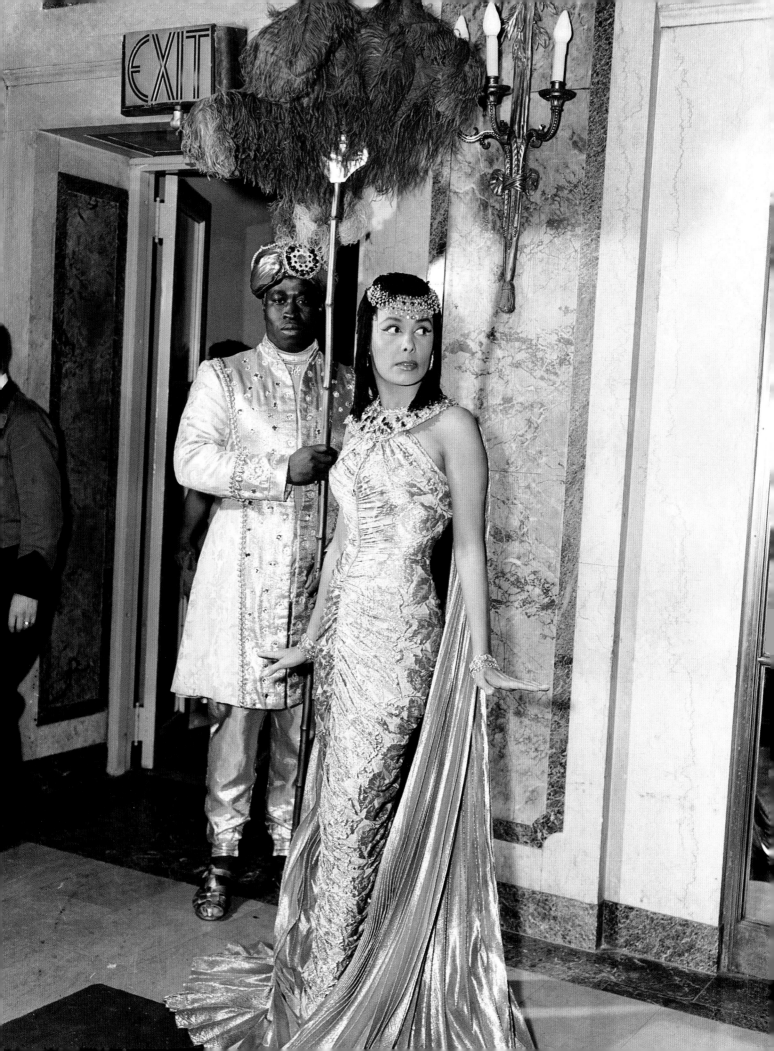

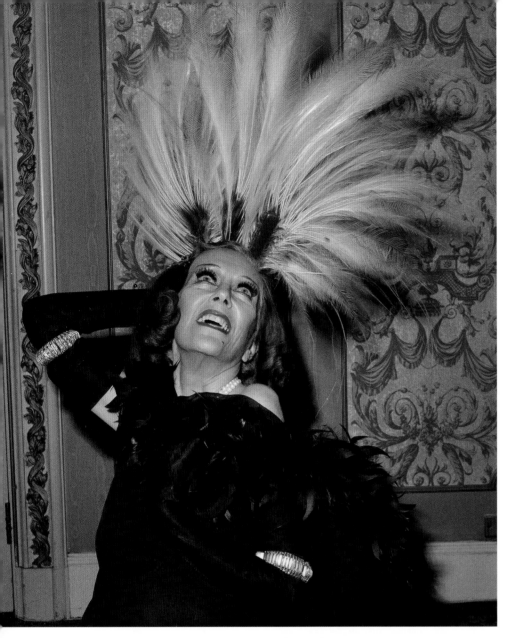

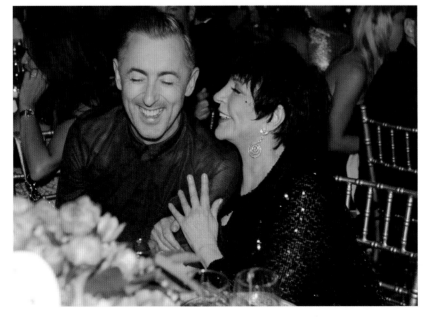

TOP: Gloria Swanson shows off her plumage at the seventh annual Fan Ball in 1956. The theme that year was Paris in the 1920s.

BOTTOM: Alan Cumming and Liza Minnelli attend the AMFAR 2013 Inspiration Gala in June of 2013.

OPPOSITE TOP LEFT: Patricia Kennedy Lawford and new husband, Peter Lawford, at their wedding reception in April of 1954.

OPPOSITE TOP RIGHT: Lauren Bacall and Barbra Streisand exit the hotel after a party for Senator Ted Kennedy's sixty-fourth birthday in 1996.

OPPOSITE BOTTOM: Patricia Neal, Carol Channing, Helen Hayes, Bernadette Peters, Burgess Meredith, and Judy Collins celebrate Miss Hayes's ninetieth birthday in October of 1990.

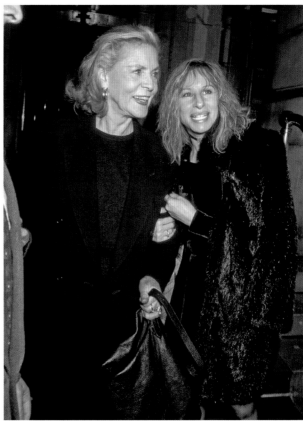

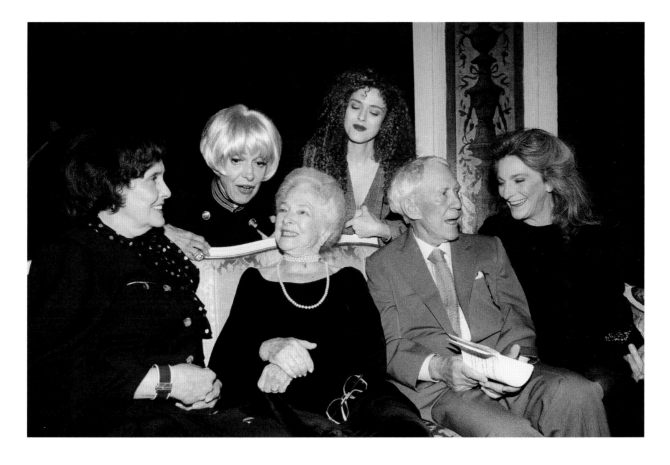

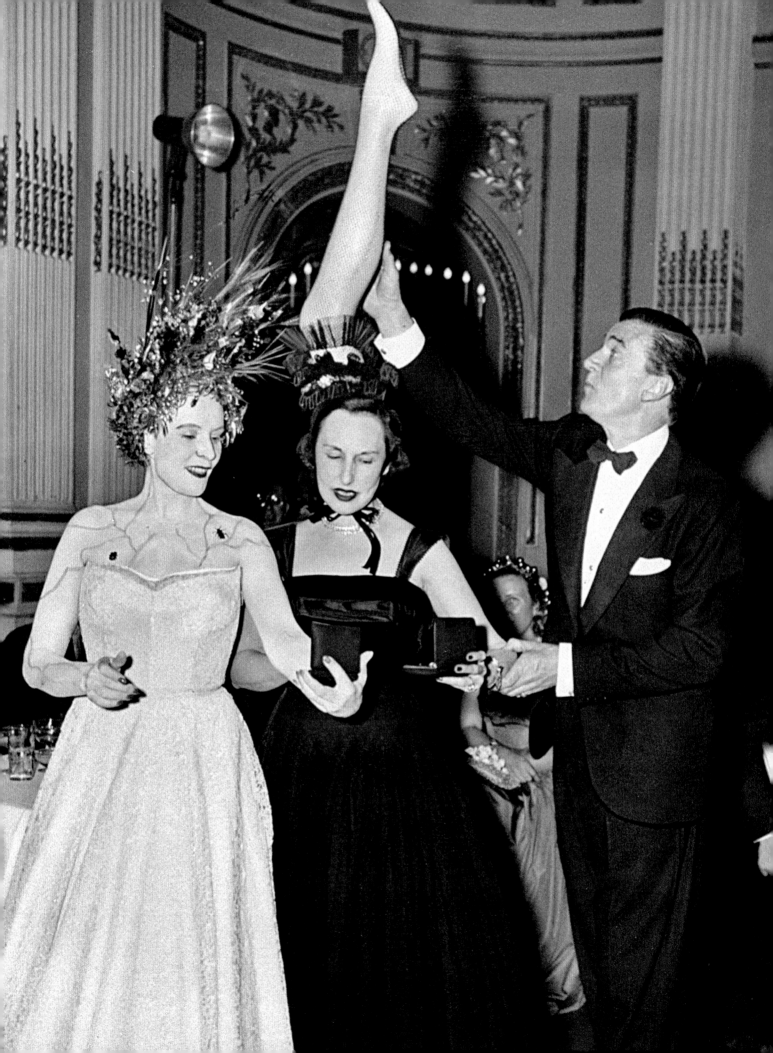

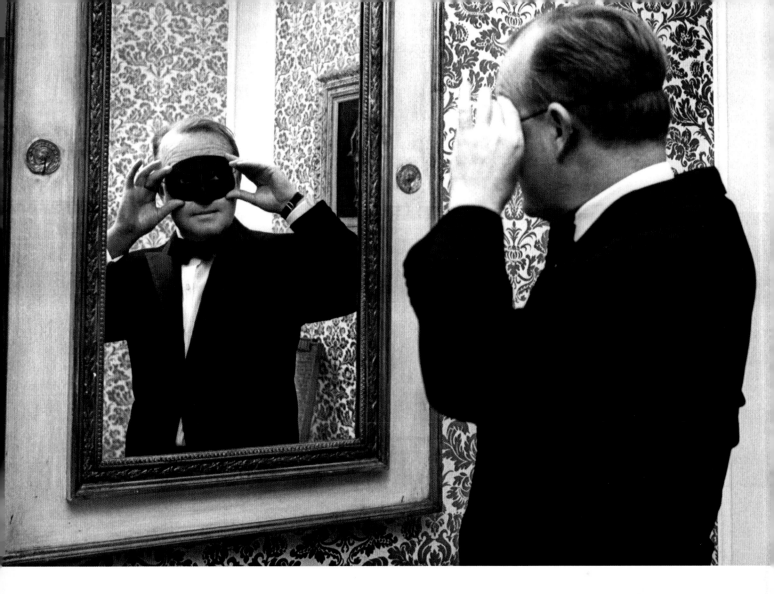

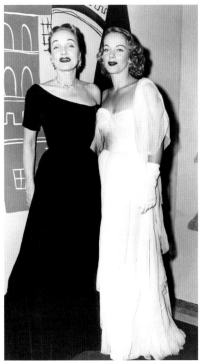

ABOVE: Truman Capote dons a dime-store mask for his Black & White Ball on November 29, 1966.

RIGHT: Marlene Dietrich and her daughter, Maria Riva, at the United Nations Ball in October of 1952.

LEFT: Walter Pidgeon examines the leg of socialite Polly Brooks Howe's headdress, which won the originality prize at the Bal de Tete in November of 1948. At left, actress and opera singer Jarmila Novotna wears the headdress deemed most beautiful.

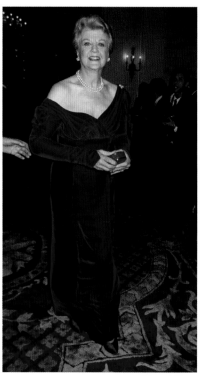

ABOVE: Truman Capote dances with a guest at his 1966 Black & White Ball, held in the Grand Ballroom. At left, the guest of honor and publishing magnate Katherine Graham dances with an unidentified man. At right, Lauren Bacall dances cheek to cheek with director/choreographer Jerome Robbins.

LEFT: Honoree Angela Lansbury arrives at the annual Red Ball in February of 1998.

OPPOSITE TOP: Ethel Merman, Lucille Ball, and husband Gary Morton celebrate Ethel's debut at the Plaza's Persian Room in 1963. Yes, the cover charge back then was four dollars.

OPPOSITE BOTTOM LEFT: Ginger Rogers, Gloria Swanson, Gwen Verdon, and Ethel Merman attend the National Hemophilia Foundation Party in 1959.

OPPOSITE BOTTOM RIGHT: Newlyweds Robert Goulet and Carol Lawrence at their wedding reception in 1963.

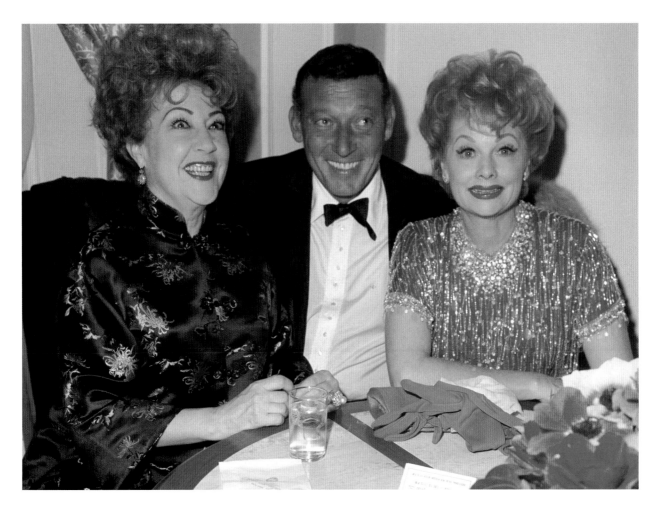

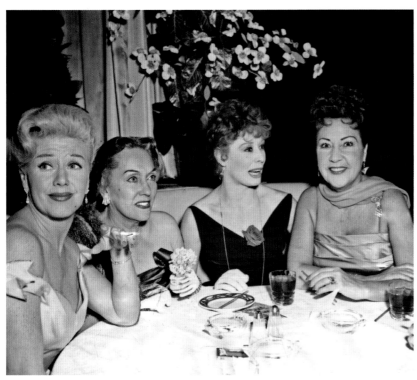

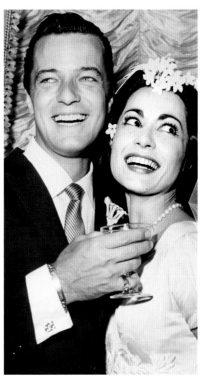

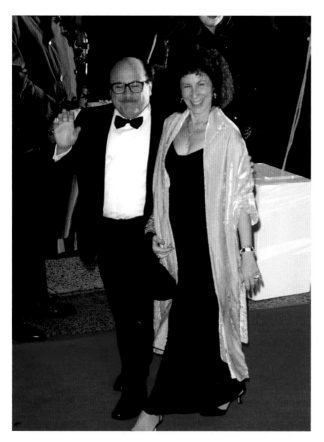

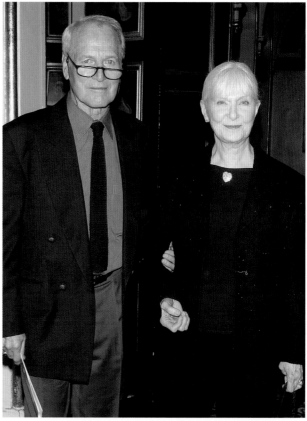

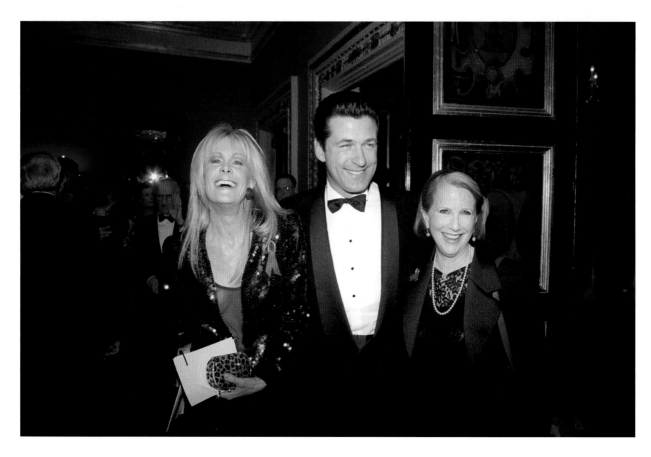

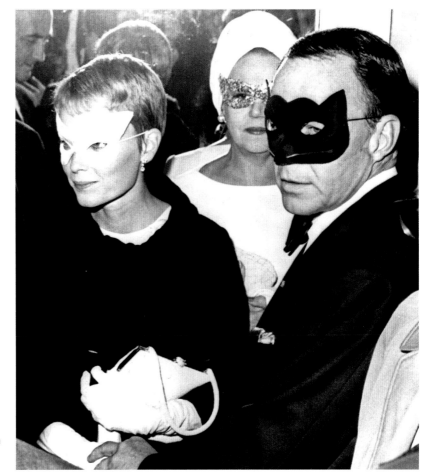

OPPOSITE TOP LEFT: Danny DeVito and wife Rhea Perlman enter the Plaza on their way to the wedding reception of Michael Douglas and Catherine Zeta Jones in November of 2000.

OPPOSITE TOP RIGHT: Paul Newman and Joanne Woodward attend "A Broadway Frolic," a benefit for their friend Tony Randall's National Actors Theatre, in April of 2004.

OPPOSITE BOTTOM: *Knots Landing* stars Joan Van Ark, Alec Baldwin, and five-time Tony Award winner Julie Harris make the scene at the gala benefit for the American Academy of Dramatic Arts in 1993. Harris received an award for lifetime achievement in the dramatic arts.

ABOVE: Frank Sinatra and new wife Mia Farrow attend the 1966 Black & White Ball.

RIGHT: Sophie Tucker and Hermione Gingold share a laugh at a party celebrating the Plaza's Golden Anniversary in March of 1957.

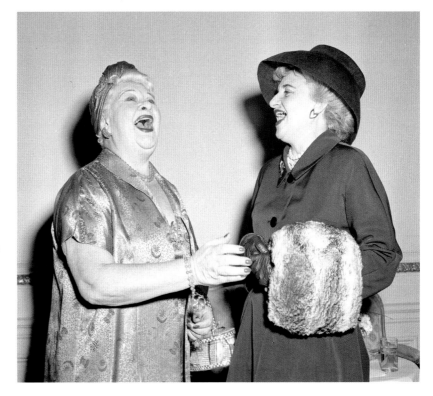

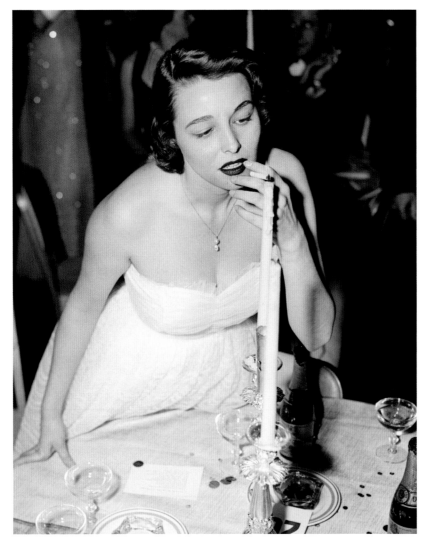

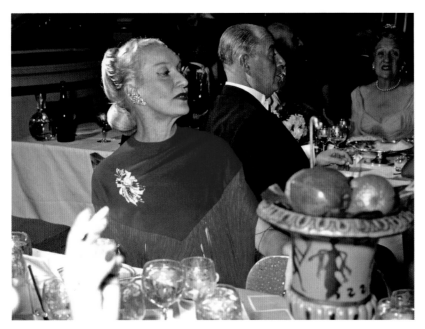

LEFT: Patricia Neal lights her cigarette from the flame of a candle in the Grand Ballroom of The Plaza at the annual Theater Ball in 1951.

BELOW: The glamorous Marusia Toumanoff—Polish princess, Hollywood fashion designer, actress, and owner of the Peppermint Lounge West—graces the Embassy Ball with her presence in October of 1958.

OPPOSITE TOP: Gypsy Rose Lee holds a gold plaque awarded to her at the annual USO Woman of the Year luncheon at the Plaza in 1969. The legendary ecdysiast is joined by Joan Crawford (left), the 1966 winner, and Pearl Bailey, winner of the award in 1968.

OPPOSITE BOTTOM LEFT: Gregory Peck and dance legends Martha Graham and Mikhail Baryshnikov attend the opening-night gala for Graham's 179th dance.

OPPOSITE BOTTOM RIGHT: Harry Belafonte and Leonard Bernstein at Bernstein's fiftieth birthday party on November 8, 1968.

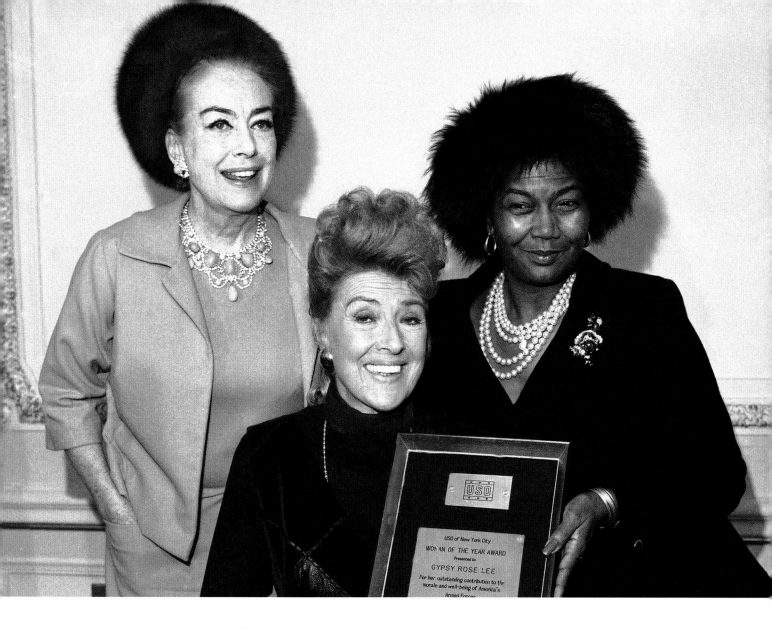

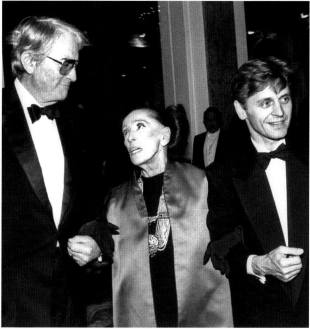

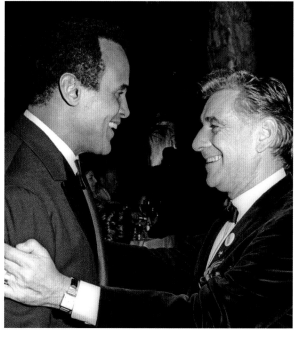

PREMIERES

Feel free to go to the movies…me, I'd rather see the stars up close and personal.
It seems that every other week the front entrance of the Plaza is roped off for
a parade of leading men and ladies promoting their latest film or play and
enjoying a well-deserved cast party. Are those bright lights flashbulbs—or do I
have stars in my eyes?

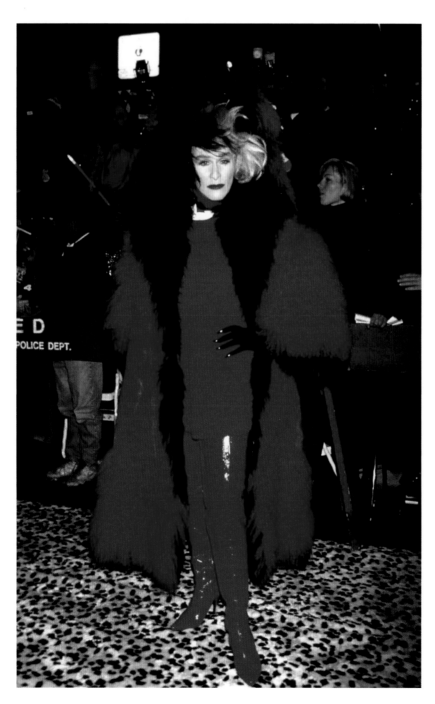

LEFT: Glenn Close makes a surprise appearance in costume as "Cruella DeVil" at the *101 Dalmatians* premiere in November of 1996.

OPPOSITE TOP LEFT: Goldie Hawn at the *Cactus Flower* premiere after party in December of 1969.

OPPOSITE TOP RIGHT: Glenn Close enters the Plaza for the premiere of *101 Dalmatians* in November of 1996.

OPPOSITE BOTTOM RIGHT: Ingrid Bergman at the *Cactus Flower* premiere after party in December of 1969.

OPPOSITE BOTTOM RIGHT: Kate Winslet at the after party for the premiere of the 2011 HBO remake of *Mildred Pierce,* held in the Grand Ballroom.

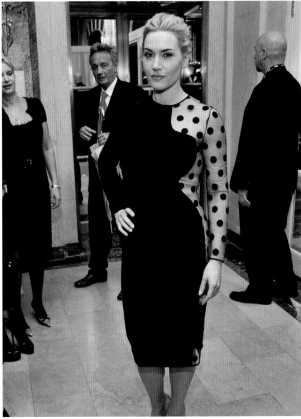

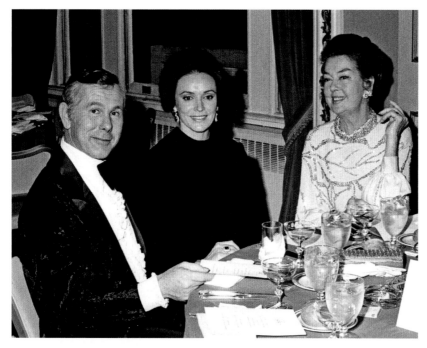

Johnny Carson, his third wife Joanna, and Rosalind Russell at the premiere party for the film *Nicholas and Alexandra* in December of 1971.

Anthony Hopkins and his wife, Jenni, attend the premiere party for the movie *A Bridge Too Far* in June of 1977.

Susan Sarandon and Tim Robbins attend the premiere of *My Best Friend's Wedding* at the Plaza in June of 1997.

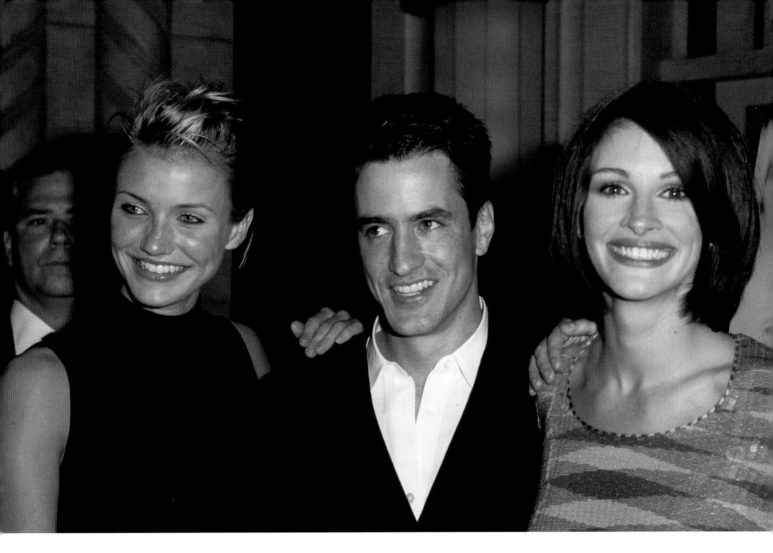

ABOVE: Cameron Diaz, Dermot Mulroney, and Julia Roberts at the New York premiere of *My Best Friend's Wedding.*

RIGHT: Jack Benny, columnist Earl Wilson, and Rosalind Russell at the *Nicholas and Alexandra* party in December of 1971.

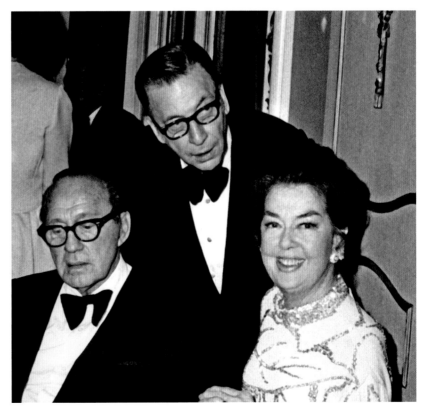

INDEX

PHOTO CREDITS

Courtesy Matt Tunia Collection: Cover, 50, 53, 54.

Photofest: pp. 6, 11, 15, 16, 17 (top), 18, 22-24, 25 (bottom), 26-29, 30 (bottom), 31, 35 (top), 37-38, 39 (top), 41, 43 (top), 44, 51, 60 (top), 62, 67, 70-73, 75-77, 79 (top), 80, (top), 81, 82, 84, 86, 87 (top), 88-91, 100, 106 (top left), 118 (bottom).

Everett Collection: pp. 12, 20, 21, 30 (top), 33, 34, 36, 39 (bottom), 43 (bottom), 65 (top), 66, 68 (top right & bottom), 69, 78, 79 (center & bottom), 80 (bottom), 83 (bottom), 97 (bottom right), 98 (top), 111 (top left), 113, 117 (top).

Alamy: pp. 14, 17 (bottom), 19, 25 (top), 32, 40, 42, 46-48, 61, 83 (top), 120, 123 (top).

Rex Images: pp. 52, 57 (top), 59, 97 (top), 98 (bottom), 99 (top), 101, (top), 102, 105 (bottom left and right), 106 (top right), 110, 111 (bottom), 115 (bottom right), 116.

Peter Carrette Archive/Getty Images: Page 35 (bottom).

Richard Corkery/NY Daily News Archive/ Getty Images: pp. 45, 94.

New York Daily News Archive/Getty Images: Page 55, 65 (bottom), 96 (top), 114 (bottom), 117 (bottom), 122 (bottom).

Bettmann Archive/Getty Images: pp. 56, 97 (bottom right), 99, (bottom), 106 (bottom left), 109, 112, 115 (top), 118 (top).

Popperfoto/Getty Images: pp. 57 (bottom), 58.

Sharland/The LIFE Picture Collection/ Getty Images: Page 60 (bottom).

Arnaldo Magnani/Getty Images: pp. 63, 64.

Silver Screen Collections/Getty Images: Page 68 (top left).

James Devaney/Getty Images: Page 74.

Ron Galella/Getty Images: pp. 87 (bottom), 101 (bottom), 103, 104, 105 (top), 111 (top right), 119 (bottom right), 121 (top and bottom left), 122 (top), 123 (bottom).

Sam Shaw/Shaw Family Archives/Getty Images: Page 92.

Anthony Barboza/Getty Images: Page 95.

Slim Aarons/Getty Images: Page 96 (bottom).

Vera Anderson/WireImage/Getty Images: Page 106 (bottom right).

Fox Photos/Getty Images: Page 107.

Taylor Hill/Getty Images: Page 108.

Express Newspapers/Getty Images: Page 114 (top).

Marianne Barcellona/The LIFE Images Collection/Getty Images: Page 119 (bottom left).

Stephen Lovekin/Getty Images: Page 121 (bottom right).

MPTV: Page 115 (bottom left).